Jessica Stockholder

Kunstverein St.Gallen Kunstmuseum

Jessica Stockholder
Vortex in the Play of Theater with Real Passion

Verlag für moderne Kunst Nürnberg

Impressum

Diese Publikation erscheint anlässlich der
Ausstellung *Jessica Stockholder – Mary
Heilmann* (Gemälde aus der Sammlung
Hauser und Wirth) im Kunstmuseum St.Gallen
18. März bis 25. Juni 2000.
This catalogue has been published on the
occasion of the exhibition *Jessica Stockholder –
Mary Heilmann* (Gemälde aus der Sammlung
Hauser und Wirth) at the Kunstmuseum
St.Gallen. March 18 to June 25, 2000.

Katalog/Catalogue:
Herausgeber/Editor: Roland Wäspe
Redaktion/Editing: Konrad Bitterli
Texte/Texts: Konrad Bitterli, Gerhard Mack,
Jessica Stockholder, Roland Wäspe
Lektorat/Proof Reading: Matthias Wohlgemuth,
Jeanne Haunschild, Gudrun Wojke,
Michele Schons
Übersetzung/Translation: Konrad Bitterli,
Jeanne Haunschild, Gerhard Mack
Photographie/Photography: Stefan Rohner,
St.Gallen

Gestaltung/Design: TGG Hafen Senn Stieger,
St.Gallen
Schriften/Types: Scala Sans
Papier/Paper: Luxokay, 150 g/m²
Druck und Verarbeitung/Printed and bound:
Druckerei zu Altenburg GmbH
Auflage/Number of copies: 1000 Ex.

© 2001 Jessica Stockholder, Kunstverein
St.Gallen, Verlag für moderne Kunst
Nürnberg, die Autoren und Übersetzer

ISBN 3-933096-60-X

Die Deutsche Bibliothek – CIP-Einheitsaufnahme
Ein Titeldatensatz für diese Publikation ist bei
Der Deutschen Bibliothek erhältlich

Die Realisierung der Ausstellung wurde
grosszügig unterstützt von:
The exhibition was made possible through
generous support by:
Kaiser + Kraft AG – Der Partner für Betriebs-
und Büroausstattung, Cham
Schuster & Co AG – Wohnkultur, St.Gallen
Stadttheater St.Gallen

Unser Dank geht an/Our warm gratitude is
due to Jessica Stockholder, Mary Heilmann,
Jay Gorney, Rodney Hill, Max Hetzler

Ausstellung/Exhibition:
Direktor/Director: Roland Wäspe
Kurator/Curator: Konrad Bitterli
Öffentlichkeitsarbeit/Public Relations:
Christine Kalthoff-Ploner
Technik/Technical support: Urs Burger,
Hugo Borner, Bruno Steiger

Inhalt / Contents

Zwischen Skulptur und Malerei Roland Wäspe

In einem Environment von Jessica Stockholder fühlt man sich ein wenig wie Alice im Wunderland. Man sieht zwar ganz alltägliche Dinge, doch diese verwandeln sich auf poetische, ja magische Weise in ein Kunstwerk. Eine Arbeit von Jessica Stockholder sehen, heisst zu beobachten, wie Gitterroste und Stoffbahnen, pastellfarbige Bodenbeläge und bunte Lego-Steine zu einem farbigen Tableau verschmelzen, das den architektonischen Raum in ein die Augen betörendes Gemälde verwandelt; ein dreidimensionales Gemälde, das man begehen kann. Ihre Installationen sind immer sehr genau in das architektonische Gefüge eines Ausstellungsraumes eingepasst und thematisieren damit dessen Struktur und Dimension. Wenn man die Säle des Kunstmuseums als regelmässiger Besucher, oder als Kurator, in sehr unterschiedlicher Belegung erfahren hat, so gewinnt dieser Aspekt eine besondere Präsenz. Kaum je wurden alle Eigenschaften der Räume, deren Dimensionen in Länge, Breite und Höhe, deren Lichtspiel wie deren Abfolge so grundlegend in eine installative Werkfolge einbezogen. Jessica Stockholder verbindet in ihrem Schaffen skulpturale Elemente mit einer malerischen Sicht, ihre Bilder erscheinen gleichsam als Volumen in den Raum geklappt. Nachdem ihr Schaffen in der Schweiz 1992 erstmals in der Kunsthalle Zürich umfangreicher zu sehen war, ermöglicht die St.Galler Ausstellung eine grossartige Wiederbegegnung mit einem Œuvre, das sinnlich und intelligent, kalkuliert und intuitiv zugleich einen entscheidenden Beitrag zur zeitgenössischen Kunst an der Schnittstelle zwischen Skulptur und Malerei formuliert.

Mit "Vortex in the Play of Theater with Real Passion: In Memory of Kay Stockholder" hat die Künstlerin ein denkwürdiges Werk geschaffen, das den ausladenden Dimensionen des Raumes selbstbewusst entgegentritt. Ein ausgelegter Linoleumboden, ein bunter Turm, zusammengesetzt aus Tausenden von Lego-Bausteinen, aufgestapelte leuchtend rote, blaue und orange Materialcontainer, ein vom Oberlicht herunterhängender, drapierter und die Höhe des Raumes ausmessender Bühnenvorhang sowie violette Wandmalereien und ein auf die Wand projizierter Lichtkegel verbinden die verschiedenen Dimensionen des gründerzeitlichen Ausstellungssaales in eine kompakte Struktur: Trotz ihrer Grosszügigkeit und Monumentalität wirkt die Installation als Ganzes nie erdrückend, bezieht sie sich in ihren Einzelteilen doch immer wieder auf den Menschen und seinen Körper. So ist einer der Materialcontainer begehbar, die Bodenarbeit zeichnet einen möglichen Gehweg durch die Arbeit vor, und eine lauschige Sitzbank lädt inmitten der voluminösen Buntwerte zum gemütlichen Ausruhen und entspannten Betrachten des projizierten Lichtkreises. Die vier Container, in den verfügbaren Industriefarben rot, orange und blau monochrom bemalt, nehmen das Thema des rechteckigen Behältnisses auf, das der Ausstellungssaal selbst ja auch ist, und überführen es vom architektonischen Massstab ins normierte Transportvolumen. Als modulare Struktur werden Behälter dieser Art weltweit als mobile Volumina gebraucht. Andererseits sind sie – das zeigt die Ausstellung – durchaus auch architektonische Form auf der Ebene eines minimalen, aber für einen einzelnen Menschen noch sinnvoll nutzbaren Raumes. Die monumentale Geste der Architektur wird damit auf den Massstab von Baubaracken herabgestuft, die in spielerischer Leichtigkeit den Oberlichtsaal in spannende Raumteilungen aufgliedern. Das beliebig kombinierbare System der Container findet in den Lego-Bausteinen seine Referenzordnung aus der Kindheit. Wer hätte nicht als Kind gelernt, in diesem kubischen System aus einer eng begrenzten Anzahl buntfarbener Teile, seine Phantasiewelt auf- oder die Welt der Erwachsenen nachzubauen. Die Strukturierung eines gegebenen architektonischen Raumes endet im privaten Bereich der Erfindung einer eigenen Welt in der Kindheit. Zugleich gelingt es Jessica Stockholder, das philosophische Modell einer modularen Konstruktion von Welt in Erinnerung zu rufen. Sie verbindet die persönliche Erfahrung der Betrachter auf verblüffend natürliche Weise mit den intellektuellen Versuchen, als Erwachsene die Sinnfälligkeit der Dinge und ihre Zusammenhänge zu erkennen. Jeder wird seine private Geschichte entwickeln, wenn er die präzise gesetzten Anknüpfungspunkte in der Installation aufgreift. Sei es die Parkbank neben den Containern, die einen Ort des privaten Seins markieren könnte, sei es die runde, orange abgetönte Scheibe, die ein Theaterscheinwerfer an die Wand strahlt und die damit die Assoziation an eine Landschaft mit Vollmond wohl nicht gänzlich abwegig erscheinen lassen mag...

Jessica Stockholders vielschichtige Installationen wirken immer irgendwie vertraut. Durch den Gebrauch von banalen Alltagsgegenständen als Werkstoff einerseits und durch die assoziativen Konstellationen, die beim Betrachter poetische Erinnerungsbilder hervorrufen. Die Konstruktion dieser dichten Environments gelingt Jessica Stockholder, indem sie kategorielle Begriffe auf die zugrundeliegende anschauliche Erfahrung des Einzelnen bezieht. In einem vielschichtigen Prozess enthüllt sie den Wesenskern des eigenen Erlebens und macht es für Aussenstehende nachvollziehbar, jedoch nicht als private Geschichte, sondern als abstrakte Analyse, der dennoch das Emotionale der individuellen Erfahrung als notwendige Grundlage erhalten bleibt. Und in ihren sorgfältig gewählten Titeln verbirgt sich immer ein präziser Hinweis auf eine mögliche Lesart des Werke.

Ihrer Installation im Hauptraum des Kunstmuseums St.Gallen hat Jessica Stockholder den Titel "Vortex in the Play of Theater with Real Passion: In Memory of Kay Stockholder" gegeben. Zu deutsch etwa: "Der Wirbel im Spiel des Theaters mit realer Leidenschaft. In Erinnerung an Kay Stockholder". Doch schon der Versuch einer Übersetzung führt in verzweigte Räume, denn die einzelnen Begriffe können nicht nur linear zueinander in Bezug gesetzt werden. Wie in der skulpturalen Arbeit sich Teilstück um Teilstück zu einem immer neu zu interpretierenden Zusammenhang fügt, so stehen auch die Wortpartikel des Titels zueinander. "Wirbel im Spiel", "Spiel des Theaters", "Theater mit dem Wirklichen", "wirkliche Leidenschaft". Liest sich der Titel nun "Der Wirbel im Spiel des Theaters mit realer Leidenschaft", oder doch vielleicht: "Der Wirbel im Spiel des Theaters mit dem Realen ist Leidenschaft"? Die Kernbegriffe jedenfalls umreissen den gedanklichen Raum: "Wirbel", "Spiel", "Theater", "Real", "Leidenschaft". Die Widmung an ihre verstorbene Mutter Kay, die sich als Pädagogin und Wissenschaftlerin intensiv mit Theaterstücken von Shakespeare befasst hat, gibt den Schlüssel zum zugrundeliegenden privaten Bereich und verbindet die Erinnerung an die Mutter und deren Interesse für Shakespeare mit der Zeit des Erwachsenwerdens und der Veränderung des Massstabes, der damit einhergeht. Alle drei Motive werden in der Inszenierung im Museum auf ebenso poetische wie sinnfällige Weise erfahrbar.

"Vortex in the Play of Theater with Real Passion" wurde im von der Künstlerin entwickelten Ausstellungsablauf ergänzt durch eine weitere, vor Ort entstandene Installation mit dem Titel "Pictures at an Exhibition", 2000, ein Werk, welches die beiden in der Gebäudeachse parallel zueinander liegenden Ausstellungsräume – den Oberlicht- und den Seitensaal – durch Spiegelwirkung optisch raffiniert miteinander verbindet. Dank einer auf die dahinterliegende Wand aufgetragenen monochromen Malerei bezieht sich die Installation als skulpturale Setzung im Raum explizit auf die Wand und damit letztlich auf den Ort der Malerei. Sie erinnert zudem an kleinformatige Werke der Künstlerin aus der Serie "Kissing the Wall", in denen der Bezug des Objektes zur Wand durch materielle wie immaterielle Verbindungen – beispielsweise Licht – hergestellt wird. Dabei wird dem Betrachter die malerische Sicht hinter dem skulpturalen Objekt sinnlich und sinnfällig vor Augen geführt. Bei "Pictures at an Exhibition" wird dieser Objekt-Malerei-Bezug in eine komplexe, mittels Spiegeln und Metallgittern räumlich kompliziert gestaffelte Struktur überführt, die ganz nebenbei einen bildnerischen Diskurs zum Themenkreis von Dingwelt, Bild und Abbild entstehen lässt.

Den Abschluss des Ausstellungsrundganges bildet im anschliessenden Seitensaal die Arbeit "Making a Clean Edge II" (Leihgabe Galerie Max Hetzler, Berlin), entstanden 1991 für das Witte de With in Rotterdam. Genauso wie dort verbindet sie auch in St.Gallen die durch die Seitenfenster sichtbare Dachlandschaft des Aussenraumes optisch mit dem "white cube" des Museums, worauf auch die langgezogene, aus mehreren Raumschichten bestehende Installation der Künstlerin Bezug nimmt. Auf der einen Seite klar gesetzte weisse Raumgrenze, auf der andern chaotische Binnenstruktur, verknüpft sich in "Making a Clean Edge II" gleichsam die Vielfalt des Lebens draussen mit der kalkulierten Nüchternheit der Kunst drinnen. Im verwendeten Material Gips und in der Struktur einer vielleicht noch begehbaren Passage nimmt die Skulptur Elemente eines Modells einer Passage von Bruce Nauman (geboren in Fort Wayne 1941) auf: "Dead End Tunnel Folded into Four Arms with Common Walls", 1980 [Tunnel mit Sackgasse, in vier Arme mit gemeinsamen Wänden aufgefaltet], das als Leihgabe aus der Sammlung Schmid seit 1988 in der permanenten Sammlung in St.Gallen gezeigt werden kann. Der Beginn der Ausstellung wird durch einen Vorraum markiert, in dem drei Serien von Zeichnungen der Künstlerin zu den neu entstandenen Instal-

lationen sowie zu einem vom Kunstverein St.Gallen herausgegebenen Multiple die Denkbewegungen von der Konzeption zur Realisation ihrer Werke aufzeigen. Hier nimmt das Schaffen der Künstlerin ihren Anfang, und in diesem Saal stehend sieht man durch drei Türöffnungen die Skulptur von Bruce Nauman, die farbigen Container des Hauptsaales und den Anfang von "Making a Clean Edge II" im Seitensaal.

Parallel zur Präsentation von Jessica Stockholder wurden siebzehn Gemälde von Mary Heilmann (geboren 1940 in San Francisco) im Kunstmuseum St.Gallen gezeigt. Mary Heilmann entwickelte seit Beginn der siebziger Jahre eine eigenständige Malerei, die persönliche emotionale Momente mit einem abstrakten Bildraum verbindet. Die Künstlerinnen sind miteinander befreundet und hatten bereits gemeinsam ausgestellt. Jessica Stockholder lud Mary Heilmann zur Teilnahme an der Ausstellung in St.Gallen ein, als sie von der Möglichkeit einer Ausleihe einer bedeutenden Werkgruppe aus der Sammlung Hauser und Wirth, St.Gallen, erfuhr. Das Zusammenspiel zweier verschiedenartiger künstlerischer Positionen, die sich in der Beschäftigung mit Malerei doch wieder berühren, ergab auch im Dialog zweier Künstlergenerationen besonders interessante Verbindungen. Durch das gleichzeitige Installieren der Werke konnten die Künstlerinnen die beiden Präsentationen visuell miteinander verbinden. Aus dem Saal mit "Pictures at an Exhibition" von Jessica Stockholder, ein Werk, das sicherlich mit Bedacht seinen Titel erhalten hat, sieht man in den Raum mit den Gemälden von Mary Heilman. Und genau in der Blickachse hängt das Bild "West", 1996, das sich durch seine ähnlichen Farben und die Streifenstruktur mit dem Lego-Turm in "Pictures at an Exhibition" verbindet.

Eine raumbezogene Arbeit von Jessica Stockholder im Kunstmuseum St.Gallen zeigen zu können war ein lange gehegter Wunsch des Kunstvereins. Bereits im Jahre 1995 konnten wir der Künstlerin bei einem Besuch im Atelier in New York unser lebhaftes Interesse kundtun. Die Ankunft ihres Sohnes Charles Pipin zeichnete sich damals bereits ab, und es war mehr als verständlich, dass Jessica Stockholder in den ersten Jahren seiner Kindheit keine grossen Projekte, die lange Abwesenheiten erfordert hätten, annehmen wollte. Um so glücklicher sind wir, dass diese eindrückliche Ausstellung schliesslich zustande kam. Es ist vielleicht sinnfällig, dass das Erwachsenwerden und die Erinnerung an die Kindheit, wie die Widmung von "Vortex in the Play of Theater with Real Passion" an ihre eigene Mutter Kay es ausdrückt, einen Kern der Ausstellung von Jessica Stockholder in St.Gallen bilden. Im Namen des Kunstvereins St.Gallen danke ich der Künstlerin für ihr grosses Engagement. Danken möchte ich auch dem Leihgeber, Herrn Max Hetzler von der gleichnamigen Galerie in Berlin, den Herren Rolf Ricke in Köln, Jay Gorney und Rodney Hill von der Galerie Gorney Bravin + Lee, New York, sowie Dr. Bernhard Bürgi und Bettina Marbach von der Kunsthalle Zürich und den vielen Freunden der Künstlerin, die sich im Vorfeld der Ausstellung tatkräftig für das Projekt engagiert haben. Die Firmen Kaiser + Kraft AG, Cham, Schuster & Co. AG, St.Gallen, sowie das Stadttheater St.Gallen haben die technische Realisierung der Ausstellung grosszügig unterstützt. Besonders verbunden bin ich den Autoren Gerhard Mack und Konrad Bitterli für das eingehende Interview mit der Künstlerin und die ausführliche Darstellung der Genese der St.Galler Ausstellung. Ein letzter Dank geht an all jene, die beim Einrichten der Ausstellung, insbesondere beim zeitraubenden Aufbauen des Lego-Turmes beteiligt waren, an die wissenschaftlichen und technischen Mitarbeiter und deren Kinder Sofie, Meret, Marvin und Linus und natürlich an Charles Pipin.

Between Sculpture and Painting Roland Wäspe

A little like Alice in Wonderland is the way you feel in one of Jessica Stockholder's environments. You see what are quite ordinary things, but transformed poetically and magically into a work of art. Looking at an installation by Jessica Stockholder means registering how metal grates and lengths of cloth, pastel flooring and bright Lego blocks merge into a colorful tableau that translates the architecture of the room into a bewitching painting: a three-dimensional painting you can walk into. If you as a regular visitor or curator have experienced the rooms in the Kunstmuseum under very different guises, its architectural aspect here receives special weight. Hardly have all the properties of the rooms – their dimensions in length, width, height, their play of light and serial order – been so radically integrated into a series of installations. In her oeuvre Jessica Stockholder brings together sculptural elements with a painterly way of seeing; her images appear to be volumes tipped into the room. After a relatively large exhibition of her work was held for the first time in Switzerland in 1992, at the Kunsthalle Zürich, the present St.Gall exhibition enables a renewed encounter with an oeuvre that is both sensual and intelligent, calculated and intuitive, and that makes a key contribution to contemporary art at the interface between sculpture and painting.

With "Vortex in the Play of Theater with Real Passion: In Memory of Kay Stockholder" the artist has once again created a memorable installation that confidently meets head-on the challenge of the sweeping dimensions of the space in question. A floor covered in linoleum, a colorful tower consisting of thousands of Lego blocks, stacked containers in bright red, blue and orange, a stage curtain as high as the room, hung and draped from the skylight, violet wall paintings and a beam of light projected onto the wall all combine with the different dimensions of late 19th-century architecture to form a compact structure. Despite its sweep and monumentality, the installation as a whole never seems overwhelming, but repeatedly refers back to its human origin and human proportions. Thus one of the containers bids you to walk in; the floor pattern traces a passage through the work, and a comfortable bench – in the midst of the dazzling volumes – invites you to while away the time by watching the projected light beams. The four containers, painted in the available industrial colors of red, orange and blue, take up the theme of square storage receptacles, which the exhibition hall itself is, and translate it from an architectural scale to a standardized volume of transportation. This type of receptacle is used worldwide as a modular and mobile structure. On the other hand it is – as this exhibition shows – an architectural form quite on the level of a minimal, but for a single person a useable, enclosed space. The monumental gesture of the architecture is thus graded down to the scale of a barracks for construction workers that playfully divides the skylit hall into absorbing subsections. The containers' freely combinational system finds its origin rooted in childhood Lego blocks. What child hasn't learned to build his/her fantasy world or reconstruct the adult world from its cubic system, its strictly limited range of colorful parts? Structuring a given architectural space culminates in the private sphere of an invention from one's own childhood world. At the same time Jessica Stockholder succeeds in bringing to mind the philosophical model of a world of modular construction. In an amazingly natural way she ties in the viewer's personal experience with an adult's intellectual attempts to perceive the obviousness of things and their associations. Each one of us will develop his/her own private narratives when s/he takes up the starting points that have been precisely positioned in the installation. Whether it is the park bench next to the containers that could be the "x" marking the spot of a private experience, or whether it is a spotlight that throws onto the wall a round orange-tinged disc that could evoke a full moon over a landscape...

Jessica Stockholder's multilayered installations somehow always seem familiar: through the use of material provided by banal, everyday articles and through the associative constellations that summon up memories in the viewer of poetical images. Her construction of these compact environments succeeds because she relates categorical concepts to the individual's underlying visual knowledge. In a complex process she unveils the essence of her own experience and makes it intelligible to outsiders, yet not as a private biography but as an abstract analysis that still necessarily keeps the emotions of an individual experience at its core. Too, a precise indication of a potential version of the work is hidden in her carefully chosen titles.

She gave her installation in the main room of the Kunstmuseum St.Gallen the title: "Vortex in the Play of Theater with Real Passion: In Memory of Kay Stockholder" (2000). Even trying to paraphrase this title leads to ramifications, for the single terms cannot only be seen in linear relation to each other. As in Jessica Stockholder's sculptural work, in which one part joins to another in an ever freshly interpretable context, so the individual words in the title stand one to the other: "Vortex in the play", "play of theater", "theater of the real", "real passion". Does the title read: "Vortex in the play of the theater with the real is passion" or perhaps: "Vortex in the play of the theater with the actual passion"? The central concepts, in any case, profile the mental terrain: vortex, play, theater, real, passion. The dedication to her deceased mother, Kay, a teacher and scholar who undertook an exhaustive study of Shakespeare's plays, gives us the key to the underlying private association and, in a poetic way, links a memory of her mother and her mother's interest in Shakespeare to a time of growing into adulthood and the accompanying change in perspective.

During the time the artist spent setting up "Vortex in the Play of Theater with Real Passion", she added a second on-site installation with the title "Pictures at an Exhibition" (2000), a work that ties in the two exhibition rooms that lie parallel to each other in the building's axis – the skylit hall and the adjoining room – by means of a subtle mirroring effect. Thanks to a monochrome painting applied to the wall behind it, the installation – in its function as a sculptural placement – relates explicitly to the wall and consequently to the site of the paintings. In addition, it recalls small-scale works by the artist from her series "Kissing the Wall" in which the relationship of the object to the wall is provided by material as well as immaterial tie-ins – for instance by light – whereby the visitor's attention is directed sensuously and quite clearly toward the painter's eye view that lies behind the sculptural object. In "Pictures at an Exhibition" this object-painting relationship is translated into a complex structure – subtly paced and graduated – using mirrors and metal grates, which, almost as an afterthought, sets up a pictorial discourse on the theme of the world of things, the mirror held up to it and the mimetic image.

The tour of the exhibition ends in the adjoining room with the work (on loan from the Galerie Max Hetzler, Berlin) "Making a Clean Edge II" created in 1991 for the Witte de With in Rotterdam. Just as then, the view from the side window in St.Gall onto the landscape of roofs outside is optically linked to the "white cube" of the museum, references which the elongated, multilayered installation takes up. On the one hand a clearly placed white delimitation of space, on the other a chaotic configuration that in combination link "Making a Clean Edge II" and art's calculated sobriety to the diversity of life on the outside. The material used is plaster and, together with its structure that allows a potential access, takes up elements from a model of a passage by Bruce Nauman (born 1941): "Dead End Tunnel Folded into Four Arms with Common Walls" (1980), which can be seen in the permanent collection in St.Gall on loan from the Schmid Collection. The beginning of the exhibition is marked by an anteroom in which three series of Kay Stockholder's drawings on the newly conceived installations as well as on a multiple issued by the Kunstverein St.Gallen show the conceptual stages of the exhibition, from its genesis to its final realization. Here in this anteroom the artist's creation profiles its origins, and standing here we see the sculpture by Bruce Nauman through three doors, the bright containers in the main hall and, in the side room, the initial part of "Making a Clean Edge II".

Parallel to Jessica Stockholder's presentation, seventeen paintings by Mary Heilmann (born 1940 in San Francisco) are shown. Mary Heilmann has, since the beginning of the 1970s, developed a unique painting style that links personal, emotional moments with abstract pictoriality. The two artists are friends and their works have already been featured together in exhibitions. Jessica Stockholder invited Mary Heilmann to take part in the exhibition in St.Gall, when she heard that a loan of a significant group of her works from the Hauser and Wirth Collection, St.Gall was possible. The concerted effort of two different artistic positions, which do in fact meet in their occupation with painting, has produced especially interesting associations, including a dialogue between two artistic generations. Because their works were installed simultaneously, the artists were able to link both presentations visually. From the room with Jessica Stockholder's "Pictures at an Exhibition", a title certainly chosen very deliberately, you look into the room containing Mary Heilmann's paintings. And exactly in the viewer's axis hangs the painting "West" (1996) that, owing to its similar colors and striped structure, ties in with the Lego tower in "Pictures at an Exhibition".

A wish long entertained by the Kunstverein has been to be able to show an environment by Jessica Stockholder in the Kunstmuseum St.Gallen. As long ago as 1995 at a visit to the artist's studio in New York we first announced our interest. The birth of a son, Charles Pipin, was then in the offing, and understandably, Jessica Stockholder, during the first years of his childhood, did not want to take on any large projects that would have called for a long absence. We are now all the happier that this impressive exhibition has finally been realized. It is perhaps evident that growing up and childhood memories are at the crux of Jessica Stockholder's exhibition in St.Gall, such as the dedication to her own mother, Kay, in "Vortex in the Play of Theater with Real Passion". I speak for the Kunstverein St.Gallen when I thank the artist for her unflagging commitment. Thanks are also due to the lenders of the exhibition: Max Hetzler from the gallery in Berlin of the same name, Rolf Ricke in Cologne, Jay Gorney and Rodney Hill of the Gorney Bravin + Lee Gallery in New York, Dr. Bernhard Bürgi and Bettina Marbach from the Kunsthalle Zürich and the artist's many friends who helped realize the project. The two firms Kaiser + Kraft AG in Cham and Schuster & Co. AG in St.Gall, as well as the Stadttheater St.Gallen, very generously supported the exhibition's technical realization. I am especially indebted to Gerhard Mack and Konrad Bitterli for their respective interview with the artist and detailed description of the genesis of the St.Gall exhibition. Finally, thanks must be extended to all those who participated in setting up the exhibition, especially in the time-consuming erection of the Lego tower, to all my academic and specialist colleagues and their children – Sofie, Meret, Marvin and Linus – and naturally to Charles Pipin.

Translation: Jeanne Haunschild

Vortex in the Play of Theater with Real Passion: In Memory of Kay Stockholder Jessica Stockholder

Das Körper-Geist-Problem aufführen:

Die Parkbank mit dem auf die Wand gerichteten Spotlicht gewährt der älteren Frau eine bequeme Sitzgelegenheit, während ihre Erinnerungen fortschweifen. Ihre Haut, so trocken wie Blätter im Herbst. Lila Winde wehen aus andern Welten. Das Licht auf der Wand breitet sich im Raum der Malerei aus, verankert in der Farbmaterie, eine flache Oberfläche nur und gleichwohl Illusion dieser Welt. Der Wind, der durch den Korridor, die Galerie, zieht, verbindet sich mit rankenden Geschichten, die von den Oberflächen der allerorten aufgehängten Bilder säuseln. Den langen Gang herunterspazierend, der mit Holzmaserungen aus Linoleum gepflastert ist, hallen die Schritte in der Stille des leeren Raumes. Der Fries entlang der Raumkante agiert wie ein Theatervorhang und lässt das Stück behaglich erscheinen. Das Ereignis wird von etwas noch Grösserem umfangen, wie Gott. Es gibt ein Schicksal. Wir sind so klein.

Mit Duplo zu bauen bedeutet Arbeit. Mit fortschreitender Zeit wird der Konstruktionsvorgang von jedem, der mit der Form spielt, aufgebrochen. Zarte, eigenwillige Hände voller Einfälle und Impulse, beim Denken kreisend, setzen die Bausteine: ein privater Raum, vielleicht mit der Öffentlichkeit geteilt. Sie, die Duplosteine, werden auf dem Hintergrund von Materialbehältern wahrgenommen, aufgetürmt von schwitzenden, hievenden Körpern. Orchestriert bespielen sie den Raum. Duplo ist zusammengesetzt wie die Container, aufeinandergestapelt und miteinander verbunden: Beide präsent mit leuchtenden Farben. Sie sind Schauspieler, Dirigenten und Regisseure zugleich.

Einen Legoturm bauen, dabei über Muster oder Bilder auf dessen Oberfläche nachdenken. Das Bild mit der inneren Struktur verbinden. Die Durchdringung der vier Richtungen erfüllt zwei Funktionen: eine Struktur zu geben und Bilder zu schaffen. Die Komplexität von Möglichkeiten, die daraus hervorgehen, gleicht den vielgestalten Beziehungen zwischen Ideen, Gedanken, Bildern und Assoziationen, die vom Werk selbst hervorgerufen werden. Erinnerung, Dekor, Wohngestaltung, Bildnerei, Oberfläche, Körper, Bewegung und – einmal mehr – Haut. Auf der Bank sitzend – die alte Frau ist nur mehr Erinnerung – exzentrische Aktivität, modrige Staubballen im Lichtkegel, von den Scheinwerfern erfasst wie eine Fotografie, ein Grammophon, das Leben spielend.

Übersetzung: Konrad Bitterli

Vortex in the Play of Theater with Real Passion:
In Memory of Kay Stockholder Jessica Stockholder

Staging the mind body problem:

The bench with the light pointing at the wall provides seating for the elderly woman whose memories are moving throughout. Skin, dry like dead leaves in autumn. Lilac winds blowing from other worlds. The light on the wall operates in the space of painting, anchored to the paint, flat surfaces, and even illusion of this world. The air that blows through the corridor that is the gallery mixes with tendrils of story telling blowing off the surfaces of pictures hung throughout. Walking down the long path paved with wood grain linoleum, footsteps echo in the stillness of the empty. The frieze running around the edge of the room acts like the curtain of a stage, making the play seem cozy. The event is bracketed by something larger, like God. There is fate. We are small.

Building with duplo is work; the work of construction is broken by each person's play with design as time moves along. The duplo are placed by soft and eccentric hands full of whimsy and impulse, swimming around internal mind space, private and perhaps shared. They, the duplo, are seen against a backdrop of containers placed by sweating heaving irritable bodies, orchestrated, while orchestrating in space. The duplo put together as the containers are, stacked and interlocking. Both present with bright, flattening colors. There are actors, conductors and protagonists.

To build a block of lego, thinking about a pattern or picture on the face of the block. Tying the picture to the structure on the inside. This interlocking in four directions serving two functions ... structure building and picture making. The complexity of possibility that emerges in this task parallels the interlocking relationship between ideas, thoughts, images, and evocations given rise to by the work. Memory, decorating, home decor, picture making, surface, body, movement and skin again. Sitting on the bench – an old woman is memory – eccentric activity, musty dust balls, in the glare of the lights, caught in the headlights like a photograph, phonograph, playing life.

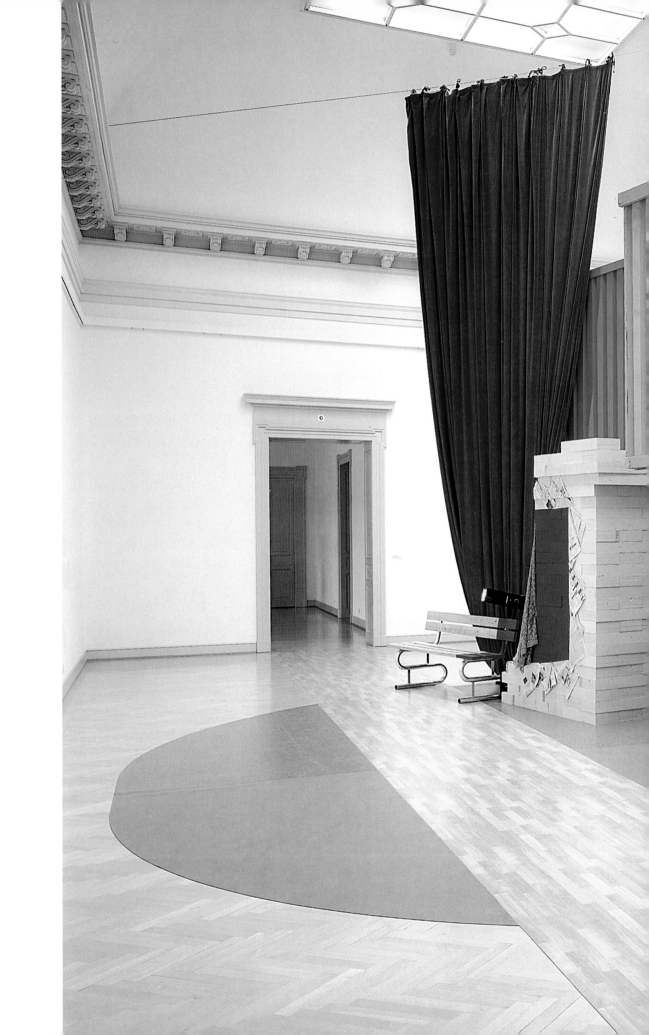

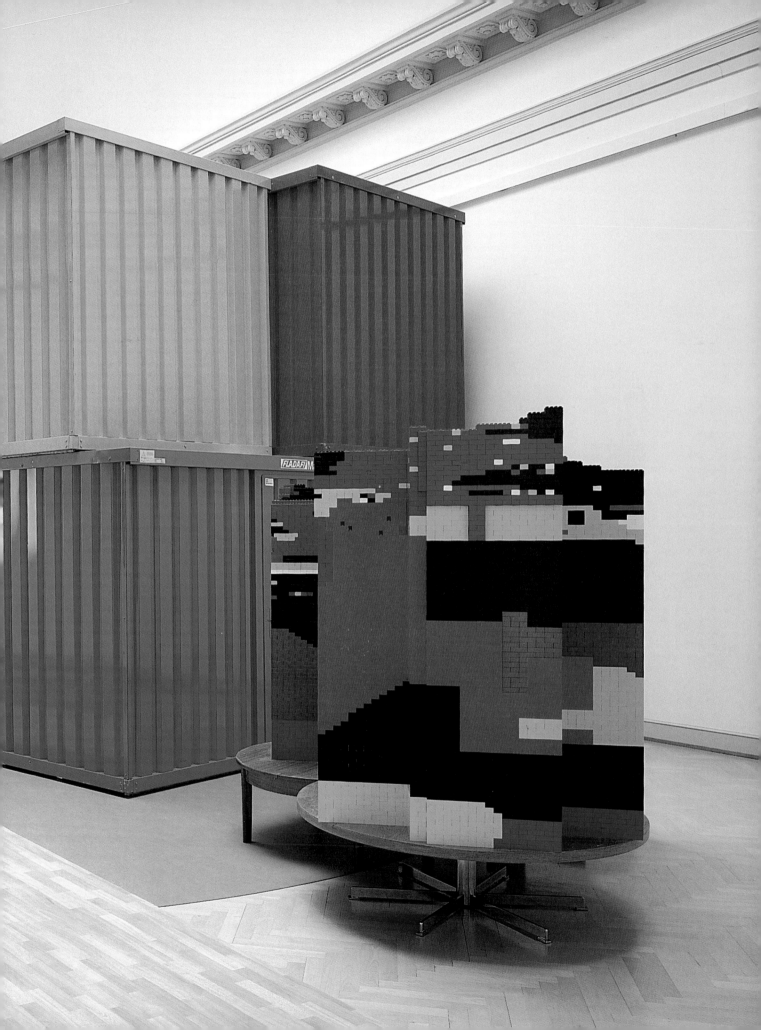

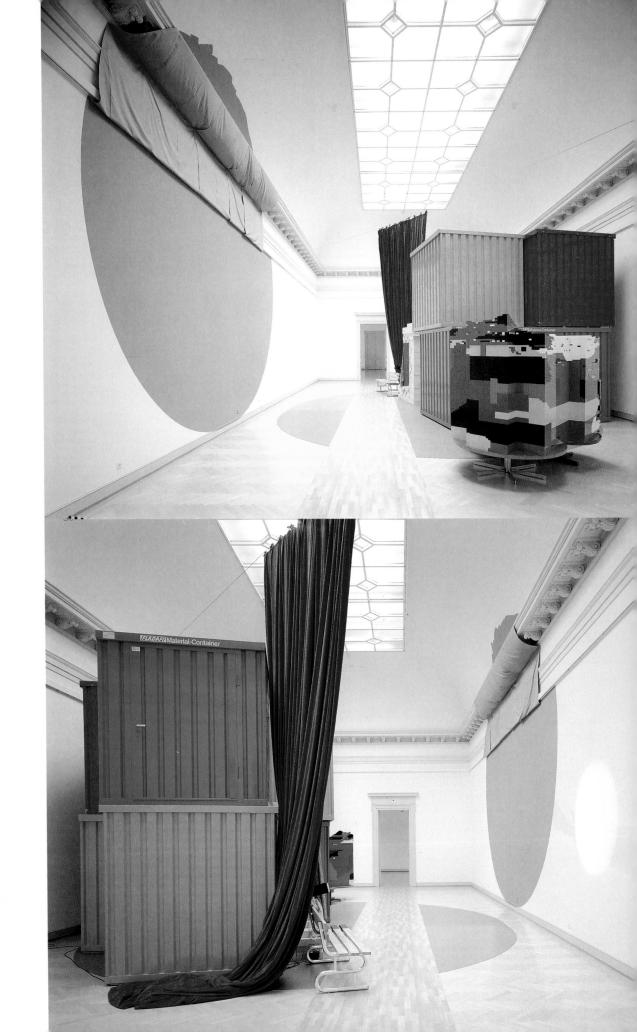

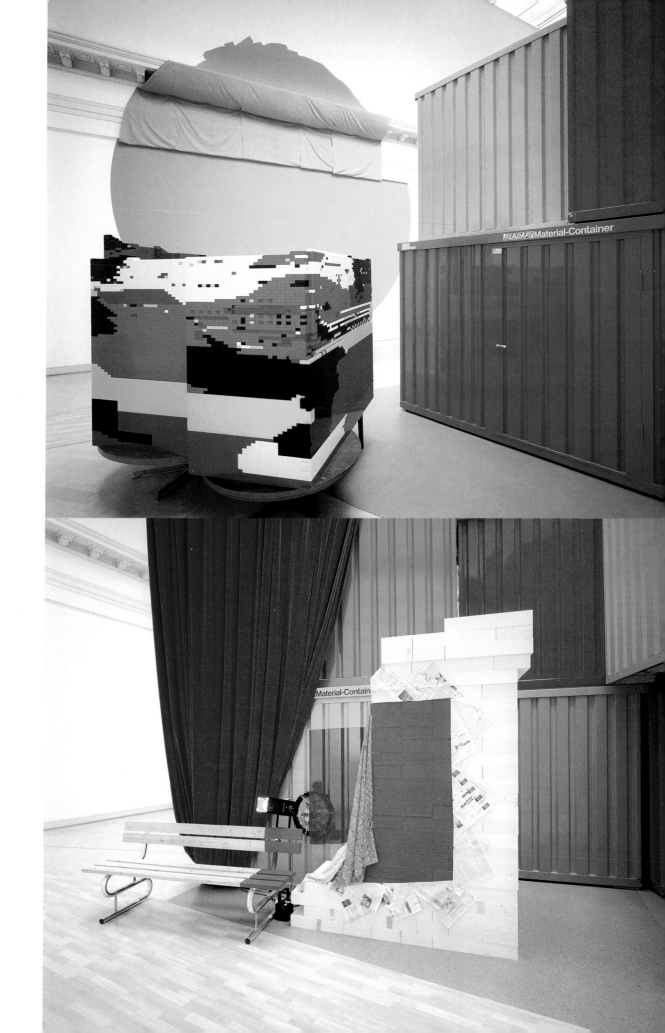

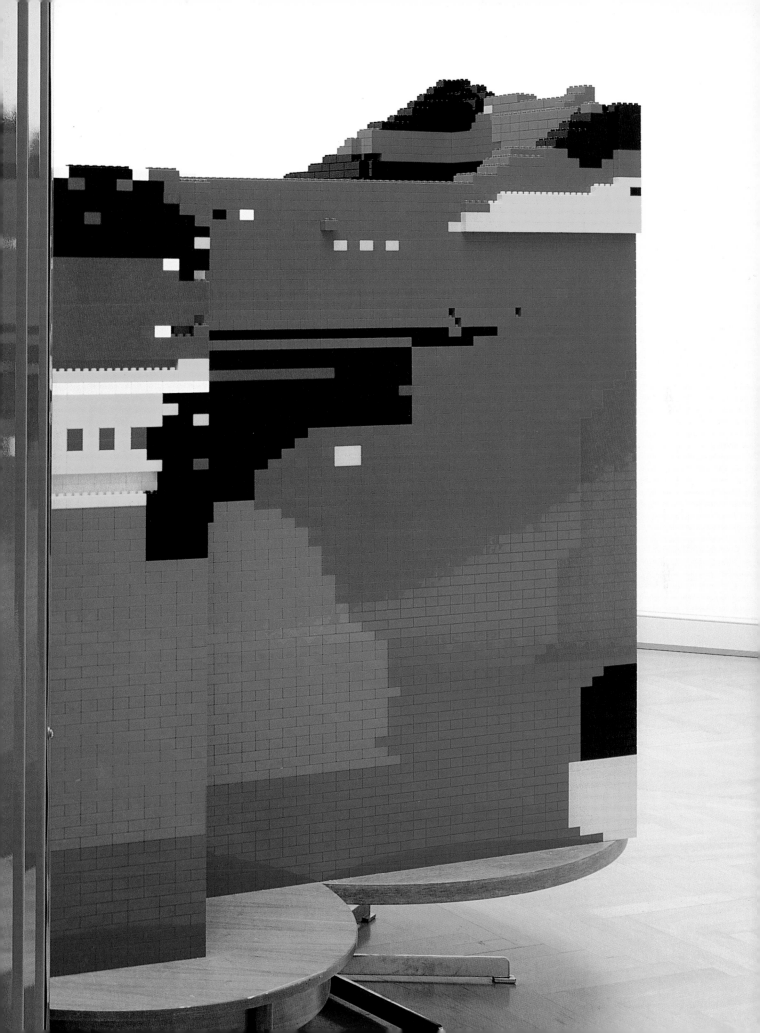

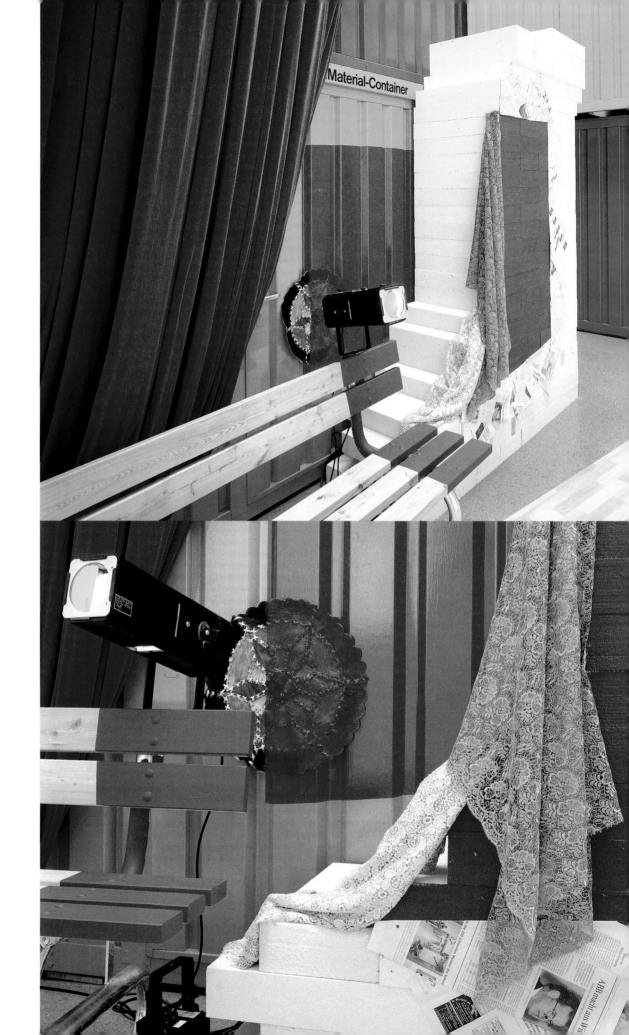

Seiten 16 – 22
Vortex in the Play of Theater with Real Passion:
In Memory of Kay Stockholder, 2000
Material-Container, Ytong-Bausteine, Holz-
tische, Duplo-Bausteine, PVC- und Linoleum-
Bodenbelag, Theaterscheinwerfer, Parkbank,
Theatervorhang, Baumwollstoff, Spitze, Fell,
Zeitungspapier, Acryl- und Lackfarbe

Pages 16 – 22
Vortex in the Play of Theater with Real Passion:
In Memory of Kay Stockholder, 2000
Containers, concrete blocks, wooden tables,
duplo, linoleum, theater spotlight, park bench,
stage curtain, cotton fabric, lace, fur, newspa-
per, acrylic and lacquer paint

"Mehr als jung und schön"
Gerhard Mack im Gespräch mit Jessica Stockholder

Mack: Jessica Stockholder, Ihr Werk ist in der Kunst der sechziger Jahre verwurzelt. Es wurde oft mit Robert Rauschenberg und mit Positionen der Minimal Art in Verbindung gebracht. Gibt es für Sie Bezüge zu diesen unterschiedlichen Positionen?

Stockholder: Ich habe mich nicht mit Robert Rauschenberg beschäftigt. Sein Werk war mir anfangs nicht so bewusst. Aber wir haben eine verwandte Ästhetik. Er arbeitet mit der Form der Collage, und er kombiniert verschiedene Materialien mit Farbe. Da gibt es eine offensichtliche Nähe. Rauschenberg hatte sicher grossen Einfluss auf mich, auch wenn ich es selbst nicht wahrgenommen habe. Ich war damals mehr an Minimal Art interessiert. Donald Judd, Frank Stella, Clifford Still – die ganze Hard Edge-Geschichte. Mich hat Abstraktion immer fasziniert. Rauschenbergs Werk wird dagegen manchmal sehr konkret. Vielleicht haben mich auch gerade wegen der grossen Nähe zu seinem Werk die Unterschiede mehr interessiert. Minimal Art dagegen verlangt vom Betrachter, beim Betrachten das Werk, den Raum darum herum und sich selbst wahrzunehmen. Minimalistische Kunst wurde als Erfahrung vermittelt, und entsprechend wurden Zeit und Raum zu zentralen Grössen. Mein Werk kommt von daher und aus einer Ablehnung der Galerie und des Museums, die dazu tendieren, Kunstwerke zeitlos erscheinen zu lassen. Beides war für mich wichtig: Minimal Art, die Künstler meiner Generation, mit denen ich studierte, und meine Erfahrung von Kunst in Museen und Galerien. Vor allem als ich jung war, hatte ich immer ein Gefühl des Absterbens, sobald ich Museen und Galerien besuchte. Aber natürlich liebe ich Museen und Kunst. Meine eigene Kunst entstand aus solch unterschiedlichen Erfahrungen.

Mack: Sie haben eine Ausbildung in Malerei und in Bildhauerei.

Stockholder: Ich studierte bei einem Bildhauer, aber ich malte. Ich malte auf Leinwand, die nicht aufgespannt war: Ich glaube, ich habe ein einziges Bild gemalt, das auf einen Keilrahmen aufgespannt war. Mich interessierte vor allem die Leinwand als Material, ich habe Gegenstände auf ihr befestigt. Damals studierte ich bei Mowry Baden, einem Bildhauer. Er kritisierte die direkt an der Wand befestigte Leinwand. Für ihn stand das Tafelbild in einer sehr präzisen Beziehung zur Wand. Dieses ist ein kleiner Spiegel der Wand, hart wie eine Wand und rechteckig wie die meisten Wände. Eine Leinwand, die nicht aufgespannt ist, hatte für ihn keine kontextuelle Beziehung zu dem Ort, an dem sie gezeigt wurde. Also begann ich, Leinwandstücke so zu montieren, dass die Wand dazwischen kam und zum Teil des Werks wurde. Dann befestigte ich Gegenstände auf der Leinwand und kombinierte Holz, Leinwand und Tuch. Ich stellte Gegenstände vor die Wand oder steckte sie durch die Wand. Dabei hörte ich nicht auf zu malen, aber mein Werk entwickelte sich gleichzeitig zu etwas anderem.

Mack: Malen Sie heute noch? In Interviews sagen Sie gelegentlich: "Ich bin noch Malerin."

Stockholder: Ich mache auch Skulptur. Für mich ist es nicht so wichtig, ob man mein Werk als Malerei oder als Skulptur bezeichnet; es kommt allerdings deutlich von der Malerei her. Bilder im engeren Sinn male ich keine. Ich mache Zeichnungen und Collagen. Oft verwende ich auch Fotografien genauso wie ich Objekte benutze. Sie führen eine andere Materialqualität und eine weitere Dimension in den Illusionsraum des Papiers ein. Ich habe auch einige kleinere Arbeiten geschaffen, die auf Glas und flach sind. Das Glas wird dabei zum Objekt, durch das man hindurchschauen kann, so dass die Wand wieder Teil des Werks wird.

Mack: Sie sind in Kanada aufgewachsen und kamen in den achtziger Jahren nach New York. Damals erlebte die Malerei ein Comeback. Künstler wie Julian Schnabel und David Salle gaben den Ton an. Wie haben Sie da ihre eigene, unabhängige Position gefunden?

Stockholder: Als ich nach New York kam, waren diese Künstler sehr gefragt, gleichzeitig wurde man aber gerade auf die Vertreter der Neo-Geo-Bewegung aufmerksam. Es gab also zwei grundverschiedene Arten, über Kunst nachzudenken. Zudem war Mowry ein sehr einflussreicher, charismatischer Lehrer. Ich hatte nicht das Gefühl, es gebe nur einen richtigen Weg in der Kunst. Als ich nach New York kam, verbrachte ich ein Jahr damit herauszufinden, wie ich da überhaupt leben wollte, wie ich Geld verdienen und zu einem Atelier kommen

könnte. Im folgenden Jahr arbeitete ich in meiner Wohnung. Dann bekam ich ein Atelier im PS 1. Chris Dercon, der inzwischen am Museum Boijmans Van Beuningen in Rotterdam arbeitet, war damals dort Kurator. Ich verschickte Dias an ein paar Galerien und konnte schliesslich mit Colin Deland von der American Fine Arts Gallery zusammenarbeiten. Im Rückblick war es ganz einfach.

Mack: Sie machen sowohl objektähnliche Werke, die Bezug zur Wand aufnehmen, als auch grosse, ortsspezifische Installationen. Wie ist es zu diesem Wechsel vom Objekt an der Wand zur grossen Installation im Raum gekommen?

Stockholder: Während der Ausbildung in Yale wurde meine Arbeit immer grösser und entwickelte sich zu etwas, das kein Objekt mehr war. Alle Werke wurden ephemer. Ich hatte darüber nie richtig nachgedacht. Ich hatte einfach keinen Platz, um die Objekte aufzubewahren. Es fiel mir auch gar nicht auf, dass ich keine Objekte mehr schuf. Als ich graduierte und nach New York zog, befand ich mich in einer schwierigen Übergangsphase. Ich wollte in meinem Wohnzimmer keine Installationen aufbauen. Das machte keinen Sinn. Schwitters hatte das mit seinem Merzbau bereits getan. Das wollte ich nicht. Nach einem Jahr beschloss ich sogar, nicht mehr als Künstlerin weiter zu arbeiten. Es war einfach zu anstrengend, einem beschissenen Job nachzugehen, um Geld für meine Kunst zusammenzukratzen, eine Kunst, von der man nicht einmal wusste, was mit ihr geschehen würde. Sobald ich jedoch damit aufhören wollte, konnte ich wieder als Künstlerin arbeiten. Ich begann kleine Objekte auf der Wand zu schaffen: Collagen mit Zeitungspapier und verschiedenen Gegenständen. Die erste Arbeit, die ich auf dem Boden ausführte, war ein Möbelstück mit darum herumgewickelter Farbe und mit einer Glühbirne, die auf die Wand zeigte. Ich nannte es "Kissing the Wall". Mit diesem Werk hatte ich eine Möglichkeit gefunden, Objekte herzustellen, die nicht nur von sich selbst handelten. Es thematisierte seine Beziehung zum Raum und zur Wand. Das konnte ich fortsetzen. Seit damals mache ich beides, kleinere Werke im Atelier und Installationen. Es war natürlich wunderbar, dass ich die Atelierarbeiten verkaufen konnte. Dazu kommt, dass die Arbeit im Atelier ein viel privaterer Prozess ist. Da bin ich allein und muss nicht bis nächste Woche fertig sein. Oft weiss ich nicht einmal, wann ein Werk fertig sein wird. Der Prozess mäandert mehr. Die Installationen dagegen sind öffentlich, performativ, sehr stressig und entstehen unter Druck. Im Atelier geht es sehr viel entspannter zu. Mir gefällt diese Balance von beidem.

Mack: Wie kam die Farbe zurück in die Objekte und Installationen?

Stockholder: Ich habe nie aufgehört, Farbe zu verwenden. Ich benutze sie wie einen Gegenstand. Dinge dienen als Äquivalente für Farben. Eine bemalte Oberfläche und ein farbiger Gegenstand haben beide ein bestimmtes Gewicht. Manchmal ist es eine Illusion von Gewicht, manchmal sind es ein reales Gewicht, Masse und Massstab. Farbe ist für mich ohne Substanz. Sie fliesst von der Oberfläche weg oder verändert sie. Ihre Wirkung ist atmosphärischer Natur, ähnlich wie diejenige von Phantasie, Dichtung und Erzählung.

Mack: Wie entscheiden Sie, wo Farbe hinkommt? Geschieht das intuitiv?

Stockholder: Das hängt vom Raum ab und davon, welche Gegenstände ich finde. Die Farbe bildet sich beim Arbeitsprozess heraus. Es gibt nicht nur eine gültige Antwort auf Ihre Frage. Es ist jedes Mal anders.

Mack: Wie entwickeln Sie Ihre Werke, etwa die grosse Installation "Vortex in the Play of Theater With Real Passion. In Memory of Kay Stockholder" im Kunstmuseum St.Gallen?

Stockholder: Normalerweise schaue ich mir zuerst den Ausstellungsraum an, mache ein paar Aufnahmen und nehme einen Grundriss mit. Dann beginne ich mit Zeichnungen. Meistens fange ich mit dem Grundrissplan an und entscheide dann, wie ich den Raum benutzen will, welche Eigenschaften mich am meisten daran interessieren. Die Frage ist schwierig zu beantworten. Ich weiss eigentlich nicht, woher meine Ideen kommen. Ich schaue eher, was geschieht.

Mack: Sie benutzen Alltagsmaterialien wie Lampen, Tische, Container oder Lego-Bausteine. Alle erzählen eine Geschichte. Wie gehen Sie damit um?

Stockholder: Ich glaube nicht, dass man mein Verhältnis zu Geschichten in Sprache angemessen beschreiben kann. Ich wähle die Materialien nicht aus, um Geschichten zu erzählen; aber man kann auch nicht verhindern, dass solche dabei entstehen. Es ist unmöglich, verschiedene Materialien zusammenzufügen

und dabei keine Geschichte zu bekommen. Ich wähle das Material so aus, dass diese linearen Erzählungen unterbrochen werden und sich nicht eine einzige Geschichte in den Vordergrund schiebt. Die Materialien bringen ihre eigene Geschichte und Narration mit, die sich direkt neben den abstrakten Setzungen bewegen, die ich treffe. Darüber bin ich sehr froh.

Mack: Wie haben Sie beispielsweise die Duplos für die St.Galler Installation gefunden?

Stockholder: Mein Sohn hat welche, die ich ihm gekauft habe, weil sie mir gefallen. Ich glaube, sie gefallen mir sogar besser als ihm. Duplos sind so interessant, weil sie so formal sind und so tolle Farben haben. Sie sind ein Baumaterial mit einem sehr kleinen Massstab. Ich wollte sie zusammen mit anderen Baumaterialen benutzen, die die übliche Grösse haben. Sie sind perfekt, so perfekt, dass ich nicht verstehe, warum ich vorher nie an sie gedacht habe oder warum sonst niemand sie vorher benutzt hat. Sie sind das perfekte Material. Daneben verwende ich Betonsteine, Ytongs. Die Duplos sprechen mit ihnen. Im vorliegenden Zusammenhang werden die Duplos zum Ort der Phantasie. Wir halten das Spiel von Kindern normalerweise für Phantasie. Aber wo liegt denn der Unterschied zwischen Kinderspielen, also den Duplos, und den Bausteinen für ein Gebäude? Beides sind doch Phantasien; die eine stammt von einem Kind, die andere von einem Architekten. Die Trennlinie zwischen beiden möchte ich befragen und verwischen.

Mack: Wie entscheiden Sie, welche Materialien Sie verwenden?

Jessica Stockholder: Wenn ich eine öffentliche Arbeit vorbereite, frage ich die Beteiligten, was vor Ort verfügbar ist. Ob es Firmen in der Stadt gibt, die ein Interesse haben könnten, die Ausstellung zu unterstützen. In gewisser Weise kann ich jedes Material verwenden; denn mein Werk handelt davon, wie Abstraktion und Materialität zusammentreffen. Das ist mit allem möglich. Andererseits allerdings auch wieder nicht: Ich wähle Dinge aus. Und wenn ich auf mein bisheriges Werk zurückschaue, gibt es rationale wie irrationale Gründe, warum ich Gegenstände wiederholt gebraucht habe. Aber darüber brauche ich mich nicht weiter auszulassen.

Hier in St.Gallen verwendete ich einen Theatervorhang, da ich seit geraumer Zeit über das Theatralische in der bildenden Kunst, besonders in der Skulptur nachdenke. Ich unterrichte an der Yale University Skulptur, und meine Kollegen fragen mich manchmal ironisch, was denn Skulptur überhaupt sei. Skulptur ist nicht mehr das, was sie einmal war. Was sie jedoch sicher zu sein scheint, ist eine Art Theater im Kunstraum. Alles, was nicht Malerei oder Fotografie ist, ist Skulptur. Sie wird einzig durch die Wände des Ausstellungsraums begrenzt. Das untersuche ich ein bisschen mit dem Theatervorhang. Aber diese Art darüber nachzudenken steht für mich meistens nicht im Vordergrund. Ein Werk ist vielmehr eine Gelegenheit für Entdeckungen. Ich frage mich nicht, was es zu bedeuten hat oder was es ist. Mir genügt es zu wissen, dass es von etwas handelt.

Mack: Beginnen Sie eine Arbeit mit bestimmten Vorstellungen, die Sie dann im Arbeitsprozess verfolgen?

Stockholder: Nicht bewusst. Mein Werk ist so vielschichtig, dass ich nicht ständig alle Aspekte gleichzeitig im Kopf haben kann. Während der Arbeit nehme ich Fragen wahr, die auftauchen; ebenso wie offensichtliche oder überraschende Elemente.

Mack: Hat Ihr Werk eine biografische Dimension?

Stockholder: Die gibt es vermutlich in jedem Kunstwerk. Ich glaube nicht, dass man etwas so Eigenwilliges wie das Schaffen von Kunst zum Beruf wählen kann, ohne persönliche Gründe dafür zu haben. Dafür muss es einen Grund geben. Meine Arbeit entspringt dem Wunsch, mich meiner eigenen Erfahrung zu vergewissern. Meine Eltern waren Akademiker. Mein künstlerisches Schaffen bot mir anfangs die Möglichkeit, meine Erfahrungen zu formulieren, ohne die Worte eines andern, ohne Worte überhaupt, zu benutzen. Es ist auch ein Versuch, Schwierigkeiten und Kämpfe anzunehmen und daraus etwas Positives zu machen.

Mack: Sie haben darauf hingewiesen, dass in Ihrem Werk eine abstrakte und eine konkrete Dimension zusammentreffen. Können Sie den abstrakten Teil erläutern?

Stockholder: Er steht in Verbindung zu Phantasie, zu subjektiver Erfahrung, die das Material für unsere Gedanken liefern. Abstraktion, denke ich, hat mit der Frage zu tun, wo unser Denken stattfindet. Sie ist

auch der Bereich des Geistes, während dem Konkreten der Körper entspricht. Mein Werk erhält dank einer abstrakten Ordnung seine Kohärenz. Zugleich fordert es die Betrachter auf, die konkreten Materialien, aus denen es hergestellt ist, wahrzunehmen. Es ist das alte Problem von Körper und Geist.

Mack: Ihre Arbeiten scheinen sich kontinuierlich zwischen einer präzisen Struktur und ihrem Auseinanderfallen in die einzelnen materiellen Teile zu bewegen.

Stockholder: Ja, die Arbeiten sind sehr strukturiert und fallen dann wieder auseinander. Und es gibt verschiedene Formen von Struktur. Im Kern ist mein Werk ziemlich geordnet, in geradezu klassischer Weise. Die Struktur ist meistens malerischer und kompositioneller Art. Meine Arbeiten basieren auf der Vorstellung eines Rahmens. Wenn man sich bewegt, ändert sich der Rahmen und mit ihm das Bild. Dabei ist es beim Umschreiten des Werkes wichtig, sich daran zu erinnern, was gerade zu sehen war und jetzt verborgen ist. Auf manche Betrachter wirken meine Arbeiten völlig unorganisiert und strukturlos. Das ändert sich aber, sobald man sich mit meinem Werk beschäftigt.

Mack: Was meinen Sie mit "klassisch"? Man würde diesen Begriff vielleicht eher mit Judd in Verbindung bringen.

Stockholder: Mein Werk erhält seine Kohärenz durch Gleichgewicht, Komposition und Ordnung. Das ist sehr konventionell. Soviel Rot mit soviel Grün, ein wenig Gelb dazu, und es ist im Gleichgewicht. Judd hätte man zu Beginn seiner Karriere nicht als klassisch bezeichnet.

Mack: Können Sie dieses Gleichgewicht für die "Vortex"-Installation in St.Gallen beschreiben?

Stockholder: Auf der Wand ist eine sehr grosse, pinkfarbene Form, die das, was sich gegenüber befindet, ins Gleichgewicht bringt. Objekte und Farben sprechen miteinander im Raum.

Mack: Und wie steht es mit der Theatralik, die Sie bereits angesprochen haben?

Stockholder: In der Geschichte der Gegenwartskunst, mit der ich aufgewachsen bin, wurde der Ausstellungsraum in Frage gestellt. Viele Künstler dachten, sie könnten ausserhalb desselben arbeiten und taten das auch. Aber ihre Werke wurden immer wieder in diesen Raum zurückgeholt, um dort vermittelt zu werden. Der Ausstellungsraum ist unser Ort der Kommunikation. Manche Künstler, zu denen auch ich zähle, haben Wände aufgeschnitten, den Raum mit Leere gefüllt oder ausserhalb des Ausstellungsraums gearbeitet. Das haben bereits Künstler wie Michael Asher, Gordon Matta Clark oder Robert Smithson entwickelt, als ich noch ein Kind war. In gewisser Weise sind alle diese Gesten inzwischen gescheitert. Heute scheinen sich Künstler für Popkultur zu interessieren, für Kino, Fernsehen, Internet, Popmusik und Mode, das sind andere Kommunikationsebenen. In einer Galerie ist das Plazieren künstlerischer Objekte ausserordentlich theatralisch geworden. Objekte funktionieren wie Requisiten oder Symbole, die auf etwas verweisen, was an diesen anderen Orten geschieht. Obwohl ich nachvollziehen kann, weshalb sich Künstler heute diesen Bereichen zuwenden, faszinieren mich immer noch konkrete Materialien und die Erfahrungen, die sie ermöglichen. Ich beschäftige mich immer noch mit den Schnittstellen von Ausstellungsraum und Kunst, mit Erfahrung im Leben. Ich liebe und verabscheue diese Trennung. Der Ausstellungsraum täuscht vor, neutral und separiert zu sein. Er ermöglicht einen ruhigen, abgegrenzten Augenblick der Betrachtung. Er macht Dinge sichtbar und verleiht ihnen Bedeutung. Er erlaubt einen spielerischen Umgang mit Materialien und dem Herstellen von Dingen, wie er sonst nicht möglich wäre.

Mack: Wir haben über die Duplos gesprochen. Steht der spielerische Umgang in Verbindung mit dem Spiel der Kinder? Hat Ihr Sohn Ihr Werk in diesem Punkt beeinflusst?

Stockholder: Mein Werk wächst und verändert sich, und ich weiss nicht, inwieweit mein Sohn Charlie zu dieser Veränderung beigetragen hat. Aber sicherlich haben sich meine Lebenserfahrung und die Dinge, über die ich nachdenke, durch ihn geändert, und das wirkt auf meine künstlerische Arbeit zurück. Wenn ich sein Verhältnis zum Herstellen von Dingen beobachte, die wir Kunst nennen, wird mir bewusst, wie wichtig diese Tätigkeit ist, ganz unabhängig davon, ob die Resultate gut sind. Sie ist schlicht fundamental. Alle Kinder zeichnen, alle lieben Knetmasse. In unserer Kultur sucht man immer nach dem Besten. Das ist ein Star-System. Mit einem Kind habe

27

ich den Wert von Kunst auf allen qualitativen Ebenen schätzen gelernt. Auch mittelmässige Kunst ist wertvoll; sie hat eine Aufgabe, sie gehört zum Menschsein dazu.

Mack: Ich möchte auf die Schnittfläche von Kunst und Leben zurückkommen. Wo findet das Leben Eingang in Ihre Kunst?

Stockholder: Kunst ist Leben. Ich habe Leben und Kunst vorhin zwischen Wohnzimmer und Galerie aufgeteilt. Eigentlich glaube ich aber nicht, dass diese Trennung stimmt. Alles, was wir entwerfen, gleich ob materiell oder konzeptuell, gibt unserem Leben einen Rahmen. Der Ausstellungsraum ist lediglich eine Erweiterung davon. Dass wir Kunst von lebensweltlichen Aufgaben getrennt haben, ist signifikant. Kunst wurde zu etwas, das nur mehr eine intellektuelle Funktion erfüllt oder Unterhaltung bietet. Ich möchte das nicht als gut oder schlecht bewerten. Es ist einfach so.

Mack: Die "Vortex"-Installation im Kunstmuseum St.Gallen ist sehr gross. Sind Sie an Masse interessiert?

Stockholder: Ich finde die Beziehung zwischen realer Masse und der Illusion von Masse spannend. Mich interessieren die Beziehungen zwischen den Dingen, weniger ihre Einzigartigkeit.

Mack: Und diese Beziehungen wollen Sie so reichhaltig wie möglich gestalten?

Stockholder: Ja, die Welt ist chaotisch und geordnet zugleich. Das beschäftigt mich. Es erstaunt schon, dass sie so geordnet ist, wie sie es offensichtlich ist. Zugleich ist sie aber ausserordentlich chaotisch und komplex. Das mag ich an dieser Welt. Damit verbunden ist auch meine Vorstellung von Schönheit. Sie hat mit einem Gefühl für Ordnung, teilweise auch für Unordnung zu tun, sie kreist um diese Vorstellungen. Und sie hat auch mit Freude und Vergnügen zu tun, die ich in meiner Arbeit glücklicherweise erlebe.

Mack: Ihre Installationen werden nach jeder Ausstellung wieder abgebrochen. Gibt es dahinter ein Konzept des Vergänglichen?

Stockholder: Heute geniesst das Ephemere ein gewisses Mass an Aufmerksamkeit. Einerseits sind viele Arbeiten, die ich im Kunstbetrieb wahrnehme, sehr beladen. Sie werden für den Verkauf gemacht. Das stimmt mich ein wenig traurig. Andererseits ist das Ephemere oft auch Inhalt von Kunstwerken. Ich selbst möchte keine Verantwortung für Gegenstände in dieser Welt übernehmen, obwohl ich sie in einigen Fällen habe. Manche Arbeiten sind für mich nur möglich, wenn ich nicht übers Herstellen eines Objekts nachdenken muss. Ich habe das Glück, dass Fotografien einen Grossteil dessen festhalten, was mir an meinen Installationen wichtig ist. Das Bildhafte ist so zentral in meiner Arbeit. Fotografien sind Bilder. Menschen sehen die Arbeiten und sprechen darüber. Auf diese Weise bleibt mein Werk lebendig.

Mack: Bei der Skulpturenausstellung in Münster 1997 waren viele Beiträge in einem Bereich zwischen Skulptur und Architektur situiert. Viele jüngere Künstler benutzen architektonische Strategien für ihre Skulpturen. Sie selbst beziehen sich auf Architektur, verwenden sie aber für Malerei.

Stockholder: Das hat auch mit dem Kontext zu tun. Historisch gesehen befanden sich Skulpturen in Gebäuden oder auf Plätzen; beides sind architektonische Situationen. Kunst, gleich welcher Art, braucht einen Kontext, wenn sie in der Welt in Erscheinung treten will. Von daher erscheint es sinnvoll, dass Künstler, die im Aussenraum arbeiten, sich an Architektur orientieren. Sie müssen die Situation miterfinden, in der sie ihr Werk zeigen können. Architektur vermittelt zwischen Mensch und Welt, zwischen dem Himmel und den Bäumen. Sie setzt einen Massstab, der dem Menschen entspricht und auf die Welt verweist. Das benötigt Kunst, die im Aussenraum gezeigt wird.

Mack: Ich dachte, diese Künstler verweisen auf die Bedeutung der Architektur als Rahmen für unsere Wahrnehmung der Welt, während Sie eher betonen, dass in erster Linie die Malerei unseren Blick prägt.

Stockholder: Ich sehe, dass Architektur der Malerei gedient hat. Insofern kommt ihr Bedeutung zu. Ich möchte lieber dieser Bedeutung nachgehen und mein Werk in ihr verwurzeln, als sie zu ignorieren.

Mack: Selbst in ihrer Aussenskulptur "Landscape Linoleum" in Middelheim behandelten Sie Natur, als wäre sie ein Gemälde. Zumindest verwandelten Sie diese in ein Gemälde. Ist das nicht eine andere Haltung, wenn man alles als Gemälde auffasst?

Stockholder: Ich glaube nicht. Gleich ob Architekt, Maler oder Bildhauer, in allen Fällen wird ein abstraktes Konzept, das Menschen erfunden haben, auf die gegenständliche Welt angewendet, werden unsere Gedanken, unser Verständnis von dem, wer wir sind und wie unsere Beziehung zur Welt aussieht, umgesetzt.
Ich gebe der Welt eine Bedeutung, indem ich eine bildhafte Ordnung mit Gegenständlichkeit und einer körperlichen Erfahrung verbinde. Architektur leistet das durchs Bauen und seinen Massstab. Beide sind für mich äquivalent, wenngleich Architektur die Anforderungen von Ökonomie und Nutzbarkeit erfüllen muss.

Mack: Ihre Arbeiten erstellen dreidimensionale Bilder. Vielleicht gibt es noch andere Beziehungen zur Architektur. Wie schauen Sie selbst traditionelle Malerei an?

Stockholder: Meine Kunst beruht auf Malerei. Ich liebe Malerei. Ich male jedoch keine Bilder und kann es auch nicht, weil ich mich im Raum eines Bildes gefangen fühle. Wenn ich versuche Bilder zu machen, fühle ich mich traurig und verärgert zugleich wegen der Macht, die ich auf der Bildfläche habe. Jede kleine Bewegung des Pinsels verändert die ganze Welt des Bildes. Andererseits bewundere ich genau das in den Gemälden anderer Künstler. Malerei ist eine ausserordentliche Konvention. Es ist erstaunlich, dass das Einrahmen einer flachen Oberfläche einen so lebendigen Raum erschaffen kann. Das wird nie verschwinden. Skulptur, was immer das auch sein mag, hat es da zur Zeit viel schwerer. Was ist Skulptur? Ein Objekt auf einem Sockel? Der Sockel hat nicht dieselbe verbindliche Kraft wie die Fläche eines Bildes.

Es ist heute sehr spannend über Bildherstellung nachzudenken, gleich ob es Gemälde, Fotografien oder dreidimensionale Bilder sind. Wofür benutzen wir Bilder, was wollen wir damit sagen, wie stellen wir sie her? Es gibt inzwischen so unglaubliche Möglichkeiten der Bildproduktion, insbesondere seit klar ist, dass Fotografien nicht einfach Abbildungen der Realität sind. Fotografie ist zu einem Äquivalent von Malerei geworden.

Mack: Welche Bilder brauchen wir heute?

Stockholder: Ich selbst distanziere mich eher von der Popkultur und den Massenmedien. Werbung und Mode hinterlassen eine schmerzliche Lücke in der Repräsentation unserer Kultur. Wir müssen diese Lücken füllen, nicht nur benennen. Wir brauchen Geschichten und Bilder, die eine umfassendere Vorstellung vom menschlichen Dasein ausdrücken, die mehr bieten als einfach jung und schön zu sein.

Mack: Ist das eine idealistische Haltung?

Stockholder: Ja, das ist eine idealistische Haltung.

Mack: Haben Sie eine Vorstellung davon, was Menschsein heute bedeuten könnte?

Stockholder: Was nach dem Tod mit uns passiert, ist eine echte Frage, die in unserer Kultur aber tabu ist. Sie wird von den Medien nicht oft gestellt. Was passiert, wenn wir sterben? Manche glauben nichts, manche wissen es nicht. Ich weiss es nicht. Ich würde gerne glauben, dass etwas geschieht. Alt zu sein, durchs Leben zu reisen, jung zu beginnen und alt zu werden, wozu ist das gut? In den Medien sind alle jung und sexy. Das ist wohl nicht die ganze Geschichte. Da muss noch etwas anderes sein. Man beginnt irgendwo und wächst und verändert sich. Seit ich vierzig bin, nehme ich Zeit deutlicher wahr. In den Medien werden die Menschen erwachsen, und das ist es dann. Ab und zu betrachten wir alte Leute, aber wir versuchen das zu verdrängen, weil wir Angst haben. Da ist doch etwas falsch, wenn wir Angst davor haben, alt zu werden. Menschsein umfasst alle diese Aspekte des Lebens.

Mack: Wie gehen Sie mit diesen grossen Lebensfragen in Ihrem Werk um?

Stockholder: Meine Beschäftigung mit Zeit und den Möglichkeiten von Erfahrung stehen in Bezug zu diesen Fragen. In der St. Galler Installation beschäftige ich mich besonders mit Erinnerung und damit, wie Erinnerung während eines Lebens entsteht.

Das Gespräch fand am 7.3.2000 im Kunstmuseum St.Gallen statt.
Übersetzung: Gerhard Mack

"More than young and beautiful"
Gerhard Mack in conversation with Jessica Stockholder

Mack: Jessica Stockholder, your work is firmly rooted in the art of the sixties and has often been connected with Robert Rauschenberg on the one hand and the traditions of Minimalism on the other. Do you feel any relation to these diverse traditions?

Stockholder: Robert Rauschenberg is not someone I have been focused on. I wasn't conscious of his work as a starting point. But his aesthetic is similar to mine. He uses collage and different materials together with paint. There is a very obvious similarity. I am sure, without knowing it, he was a big influence. But I am more excited by Minimal Art. Donald Judd, Frank Stella, Clifford Still – Hard Edge things. I have always been excited by abstraction. Rauschenberg's work tends to be very literary. Perhaps because of the obvious closeness between my work and his I have been more interested in the differences. Minimalism on the other hand asked you to be aware of yourself looking at the work and at the space next to the work as well as the work. Minimal work was presented as an experience and consequently time and space became focal points. My work grows from that, and in opposition to the gallery and the museum which ask things to be timeless. So both minimal work, the people I was studying with, conversation around me at that time and my experience of art in museums and galleries were important. I always felt a kind of deadening when I went into museums and galleries; more when I was younger. Though I also love museums and art. My work grew from those experiences.

Mack: You were trained as a painter and as a sculptor.

Stockholder: I studied with a sculptor, but I was painting. I painted on unstretched canvas: I think I made one painting on a stretcher. I was interested in the material of the canvas and I stuck things onto it. I was studying with Mowry Baden, who was a sculptor and very critical of the unstretched canvas on the wall. He talked about the context that easel painting has in relationship to the wall. It is a small mirror of the wall, it is hard like the wall and it is rectangular like most walls. He criticized unstretched canvas as having no contextual relationship to the place in which it was shown. So I started to use pieces of canvas with the wall between them, with the wall becoming part of the work. Then I was sticking things onto the canvas and I began to use pieces of wood and canvas and cloth. I put things in front of the wall and through the wall. So I didn't stop painting. The work slowly grew into something else as well.

Mack: Do you still paint? In interviews you usually say "I am still a painter".

Stockholder: I am a sculptor, too. It doesn't matter to me so much, whether a work is a painting or a sculpture; but it clearly grows from painting. I don't make paintings. I make some drawings and collages. I often use photographs like I use objects. The photographs introduce a different material and a different kind of space into the illusionistic space of the paper. I have also made many smaller works that are flat on glass. The glass is an object that you can see through so the wall again becomes part of the work.

Mack: You grew up in Canada and moved to New York in the eighties. At the time New York had seen a revival of painting. Artists such as Julian Schnabel or David Salle were very popular then. How did you manage to find your own position when you moved to New York?

Stockholder: I moved to New York when those people were hot, and also the Neo-Geo people were just getting attention. There were two very different ways of thinking about things. And Mowry was a very influential, charismatic kind of teacher. I didn't feel that there was just one way to do things. When I moved to New York I spent a year figuring out how to live there, how to earn money and have a place to work. The next year I spent working in my apartment. After that I got a studio at PS 1. Chris Dercon, who is now at the Boijmans-Van Beuningen in Rotterdam, was curator there at that time. I sent some slides to a few galleries and ended up working with Colin Deland at the American Fine Arts Gallery. So in retrospect it was easy.

Mack: You make object-like works relating to the wall as well as large site-specific installations. How did you move from objects on the wall to big installations in the room?

Stockholder: Through school the work developed into something that was big and not object-like. It was all temporary. I never thought about it. I had no place to store objects. I didn't notice that I wasn't making objects. Finishing grad school and moving to New York was a very difficult transition; I didn't want to make installations in my living room. It didn't make sense. I guess Schwitters did that with his "Merzbau". But it wasn't what I wanted to do. After a year I actually decided not to be an artist because it was too painful having a shitty job and trying to figure out how to earn money for this art that who knew what would happen with. As soon as I decided not to be an artist I was able to work again. So I started to make small objects on the wall. They were kind of collages with newspaper and different kinds of objects. The first piece I made on the floor was a piece of furniture with paint wrapped around it and a light that was pointing at the wall. It was called "Kissing the Wall". With that piece I had discovered a way to make an object that wasn't all about itself. It was about the way it was in relationship to the room and to the wall. That opened up doors to a whole way of working that I found possible. Since then I have been making smaller studio-based work and installations. And it is wonderful that I have been able to sell the studio work. But also, working in the studio is a much more private process. I am in my studio alone. I don't have to get finished next week. I don't even know when it will be finished. It is a much more meandering and private process. The installation work is public, performative, very stressful and pressured, whereas in my studio it is much more relaxed. I like this balance.

Mack: When you started making objects and installations how did the paint come in again?

Stockholder: I never stopped using paint. I use paint as an object. I started to use objects as equivalents to paint. A painted surface and a colored object both have weight. Sometimes it is an illusion of weight, sometimes it is real weight, mass and scale. And the color seems to me always to be something insubstantial. It floats off the surface or changes the surface. So the action of the color is atmospheric, analogous to fantasy and fiction and story telling.

Mack: How do you decide where to put color on? Is it intuition?

Stockholder: It is responsive to what the room is like and to what objects I find. The color builds through the process of working. There is no one answer to that question. It is always different.

Mack: Can you describe how you develop your pieces, the big installation "Vortex in the Play of Theater with Real Passion: In Memory of Kay Stockholder" at the Kunstmuseum St.Gallen?

Stockholder: I usually go and see the space first, take some pictures and leave with a floor plan. Then I make drawings. Usually I start with the plan and decide how I am going to use the room, what qualities of the room I am interested in. It is very hard to answer. I don't really know where my ideas come from. I see what happens.

Mack: You use everyday materials such as lamps, tables, containers, Legos. These materials all seem to tell some kind of story. How do you deal with that?

Stockholder: I don't think that words exist to describe properly my relationship to stories. I don't choose materials to tell stories, but inevitably stories are told. It is impossible to put materials together and not have a story arise. I choose materials to disrupt those stories, so that there is no one story that comes to the fore. Materials come with histories and narratives that sit next to the abstract things that I am doing. I am really glad for that.

Mack: How did you, for example, come across those duplos in the St.Gall installation?

Stockholder: My son has them, because I bought them for him, because I like them. At the moment I like them more than he does. Duplo is interesting because it is so formal and has such great color. It is a building material that has a very small scale and I have enjoyed using it in relationship to other building materials of regular scale. It seems perfect, so perfect, that I don't understand why I never thought about it before, or why somebody else hasn't used it. It seems like a perfect material. But I am also using concrete bricks, Ytong they are called here. The duplo speaks to them. In this context the duplo becomes this place of fantasy. We are used to thinking about child's play as fantasy. But what is the difference really between child's play, the duplo and bricks in a building? They are both fantasies; one is of a child and the other an architect. I like the line between the two to be questioned and blurred.

Mack: How do the decisions on materials take place?

Stockholder: When I make a public piece I ask people to let me know what is available – if there are companies that they know about in town that might be interested in sponsoring the show. In some ways it is possible for me to use anything because the work is primarily about how the abstract thing that I do meets material. And it really could be anything on some level. In another way, obviously it is not anything. I chose things. And looking through the work retrospectively there are both personal and more public reasons why I use things repetitively. I don't find it necessary to be more articulate about this.

Here in St.Gall I used a theater curtain as I have started more recently to think about theater in art and in sculpture particularly. I am teaching in the sculpture department at Yale and my colleagues sometimes ask me with humor what sculpture is. It is not what it used to be. But one thing it seems to be is a kind of theater in the art space. Anything that is not painting or photography is sculpture. It is bound by the walls of the exhibition space. I am exploring that a little with the theater curtain. This way of thinking is rarely in the foreground for me. The work is more often an occasion to discover things. I don't worry about what the work means or what it is. I know it is about something.

Mack: Before you start working on a piece do you have particular ideas in mind that you try to follow?

Stockholder: Not in a way I am aware of. The work is so layered that I couldn't consciously keep track of all the pieces in my head at once. As I work I am aware of questions that come up and things that seem obvious and others that are surprising.

Mack: Is there a biographic dimension in the work?

Stockholder: I think there is in everybody's work. I don't think you can choose something as eccentric as making art and not have a personal reason for doing it. There has to be a reason. My work comes out of a desire to ascertain my own experience. My parents were academics. My work began as a way for me to articulate my own experience without somebody else's words, without words at all. It is also an attempt to take difficulty and struggle and make something positive from it.

Mack: You pointed out the abstract that meets the concrete in your work. What would that abstract part be?

Stockholder: It is related to fantasy, subjective experience, which is the material of our thoughts. Abstraction is related to the question, where is our thinking? Also, abstraction is like the spirit and concrete is like the body. My work coheres by virtue of an abstract order. But at the same time it asks you to be aware of the material of which it is made. The old mind-body problem.

Mack: Your pieces seem to be at the point where they are continuously changing between being a concise structure and splitting up in its single material parts.

Stockholder: Yes, the work comes together as very structured and then falls apart. And there are different forms that structure the work. At its core the work is quite structured and almost classical. The structure is mostly a pictorial and compositional structure. My work depends on some sense of framing and as you move the frame shifts and the picture changes. But it matters that when looking at one side of the work you know about the side you can't see. I know that to some eyes my work looks utterly disorganized and unstructured. But as people become more familiar with my work this often changes.

Mack: What do you mean by classical? One would rather use that term for a Judd piece.

Stockholder: My work depends on balance, composition and order to cohere. This is very conventional. This much red with that much green and a little yellow and it's balanced. Judd would not have been called classical at his beginning.

Mack: Can you describe this balance in the "Vortex" piece?

Stockholder: On the wall there is a very large pink shape that balances what is on the other side. Objects and colors speak to each other across the room.

Mack: And what about this explicit theatricality of the piece, which you already referred to?

Stockholder: In the history of contemporary art I grew up with, exhibition space has been challenged. Many artists thought they could work outside it and they did. But the work is always brought back to be shared, because exhibition space is our shared point of communication. People, myself included, cut into the walls, filled the space with nothing, worked outside. This was happening when I was a kid with Michael Asher, Gordon Matta Clark, Smithson. It has become clear that all those gestures, on one level, failed. Now artists seem to be interested in engaging popular culture, movies, television, the Internet, pop music and the fashion world – other points of shared communication. In the gallery object making seems to have become very theatrical. The objects act as props or symbols that reference what is happening in these other places. Though I have a feeling for why people have turned in this direction I am still excited by working with material and by how material creates experience. I am still concerned with the intersection of exhibition space and art, with experience in life. I both love and hate this separation. Exhibition space pretends neutrality and separateness. It provides a quiet framed moment of contemplation. It points to things and says that they are important. It makes possible a kind of playfulness with material and with building things that isn't possible elsewhere.

Mack: Coming back to the Legos I wonder whether the playfulness you mentioned is connected to the playfulness children have and whether your own child changed your work?

Stockholder: My work has grown and changed and I do not know how my son Charlie has contributed to changing it, but I think that my experience of life and the things that I think about have changed as a result of having him and I bring that to my work. Having a child and watching his relationship to making things that we call art makes me realize and appreciate the importance of the activity, quite aside from being good at it. It is so fundamental; all children draw; they all love playdough. In our culture we are always looking for the best. It's a star system. Having a child I am more appreciative of the value of art making on all levels. Mediocre art is valuable; it serves a function; it is part of being human.

Mack: I want to touch on the intersection of life and art once again. Where does the life part come into your work?

Stockholder: Well, art is life. I have spoken about life in the living room and art in the gallery – actually I don't think this divide holds true. The things we construct both physically and conceptually bracket our lives. The gallery is just an extension of that. That we have separated art making from function is significant. Art has become something that has only an intellectual function or a kind of entertainment function. I don't think this is good or bad. It just is.

Mack: The "Vortex" installation at the Kunstmuseum St. Gallen is very large indeed. Are you fascinated by mass?

Stockholder: I am excited by the relationship between real mass and the illusion of mass. I am interested in the relationship between things rather than in their singularity.

Mack: And the relationship should be as rich as possible?

Stockholder: Yes, I am interested in the fact that the world is chaotic and ordered. It is amazing that it is as ordered as it is. But it is extraordinarily chaotic and complex. That's what I like about the world. Beauty is connected to a sense of order, in part, or disorder, but it pivots around that notion. It also has to do with enjoyment and pleasure, which I am happy to have in my work.

Mack: Your installations are taken down at the end of an exhibition. What do you think about the ephemeral?

Stockholder: There is some focus on the ephemeral now. On the one hand most of what I see in the art world at the moment is very packaged. People are making things to sell. I find that a little sad. On the other hand the ephemeral is often the subject of artists' work. I don't like being responsible for objects in the world, though I am responsible for some. Some things are only possible when I don't have to think about making an object. I am fortunate that photography captures a big piece of what matters to me. The work is so much about the

pictorial. And photographs are pictures. People do see and talk about the works. The pieces stay alive that way.

Mack: At the sculpture exhibition in Münster in 1997 there were a number of works playing with the idea of being something between sculpture and architecture. Many younger artists use architectural strategies for sculpture. You refer to architecture but you use it for painting.

Stockholder: That has to do with the context, too. Historically sculpture has been in a building or in a plaza, both architectural frameworks. Art, whatever it is, has to be presented to the world via some context. So it makes sense that artists working outside would veer towards architecture. They have to invent the vehicle by which they present their work. Architecture mediates between people and the world and the sky and the trees. It establishes a scale that both matches a human being and speaks to the scale outside itself. Something has to do that for art outside.

Mack: I thought these artists made a statement about the importance of architecture as a frame of our view on the world, whereas you seem to say it is primarily the painting that frames our view.

Stockholder: I see that architecture has been a vehicle for painting. And as such it has significance. And rather than just ignore that significance I'd rather carve into it and use it and root what I have to say there in a more complex way.

Mack: But even in your outdoor piece "Landscape Linoleum" in Middelheim you handled nature as if it were a painting or at least you turned it into a painting. Isn't that a different attitude, to turn everything into a painting?

Stockholder: I don't think so. It seems to me that in all cases, if you are an architect, a painter or a sculptor you are taking something abstract, something conceptual, invented by human beings, and imposing it on the material world. In all cases it is our thought, our sense of who we are and what our relationship to the world is that has been made. I make sense of the world by using pictorial order meshed together with material and physical experience. Architecture makes sense of the world through building and scale. I see them as kind of equivalent in some way. Though architecture as a field has to serve the needs of economy and habitation.

Mack: Your work gives three-dimensional images. Maybe there is another relationship to architecture. How do you look at traditional paintings?

Stockholder: My work depends on painting. I love painting. I don't make paintings and can't because I feel trapped in the space of a painting. When I try to make paintings I feel sad and angry at the amount of power I have in that frame. Every small movement of the paintbrush changes the whole world of the painting. But on the other hand, I love exactly that in other people's paintings. Painting is an extraordinary convention. It's amazing that framing a flat surface can create such a lively space. It will not go away. Sculpture, whatever sculpture is, is a much more difficult thing right now. What is sculpture, an object on a pedestal? The pedestal doesn't have the same influence that the painting space has.

It is an interesting time to consider image making, no matter whether it is a flat painted image, a photograph or a sculptural image. What are images used for? What do we want to say with how we make them? We have such enormous facilities for image making now. It is now so clear that the images produced by photography are not true, as we can mess with them so easily. Photography has become more equivalent to painting.

Mack: What images would we need today?

Stockholder: I myself am not in love with popular culture and media. Advertising and fashion leave something to be desired as a representation of our culture. We need something that fills in the gaps rather than just pointing at them. Something that provides stories and images that express something larger about being human; something more than just being young and beautiful.

Mack: That's an idealistic stance?

Stockholder: Yes, that is an idealistic stance.

Mack: Do you have an idea what being human might be today?

Stockholder: What happens to you after you die is a real question, one that is taboo in our

culture. It is not a question often raised by the media. But really, what happens after we die? Some people believe nothing; most people seem not to know. I don't know. I would like to believe that something happens. And being old, traveling through life, starting young and getting old. What is this for? In the media everybody is young and sexy. That's not the whole story. Something else has to be going on. You start somewhere and you keep growing and changing. When I turned 40 my awareness of time grew. In our media people grow up and that's it. Occasionally we look at old people, but we try not to because we are scared. Something is wrong that we are scared of getting old. Being human involves all of these parts of life.

Mack: And how do you deal with these big issues of life in your work?

Stockholder: My interest in time and the nature of experience is related to these questions. In this work here in St.Gall I am particularly concerned with memory and how memory builds through life.

This interview was held at the Kunstmuseum St.Gallen on March 7, 2000.

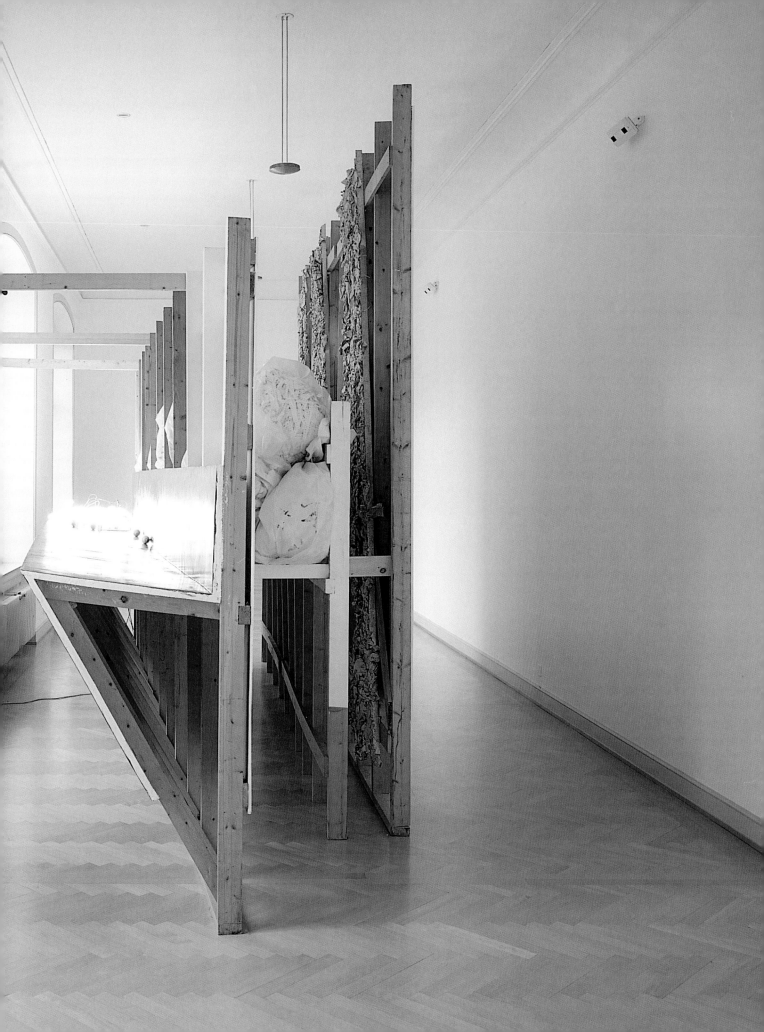

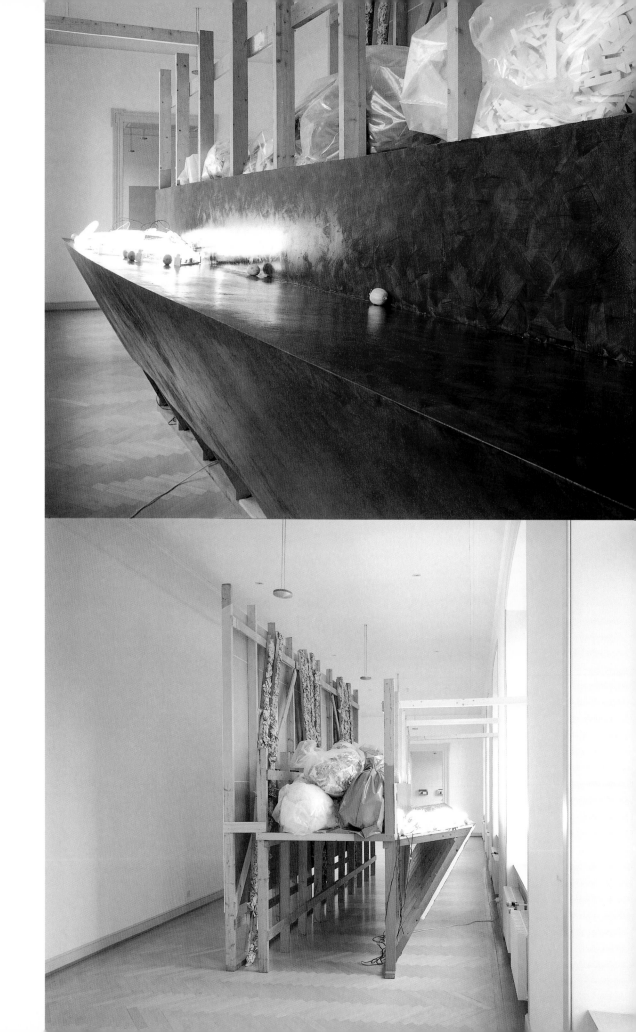

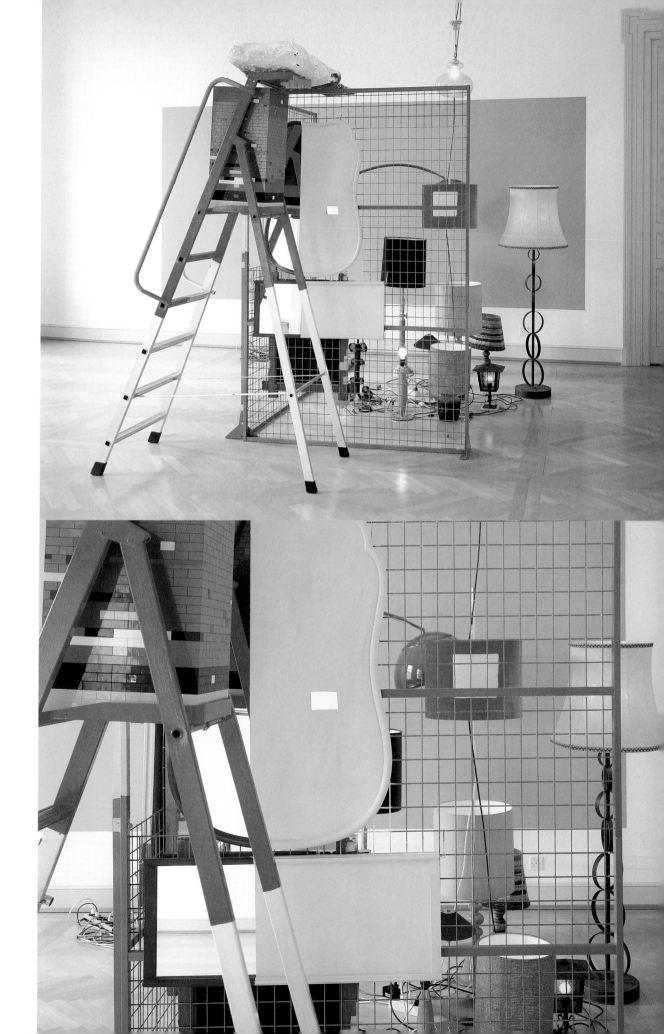

Seiten 36 – 38
Making a Clean Edge II, 1991
Holz, Styropor, Gipskarton, Gips, Plastiksäcke,
Papier, Fluoreszenzröhren, Acryl- und Spray-
farbe, 12 Zitronen
Leihgabe Galerie Max Hetzler, Berlin

Pages 36 – 38
Making a Clean Edge II, 1991
Wood, polystyrene, plaster, plastic bags, paper,
fluorescent lights, acrylic and spray paint, 12 le-
mons
Courtesy Galerie Max Hetzler, Berlin

Seite 39
Pictures at an Exhibition, 2000
Metallgitter, Aluminiumleiter, Lampen, Glüh-
birnen, Elektrokabel, Spiegel, Duplo- und
Lego-Bausteine, Acryl- und Emaillefarbe, selbst-
klebendes Stoffband

Page 39
Pictures at an Exhibition, 2000
Metal lattice, aluminum ladder, lamps, light
bulbs, electric hardware, mirrors, duplo, lego,
acrylic and enamel paint, adhesive textile tape

Von der Konzeption zur Realisation
Zur Genese von "Vortex in the Play of Theater with Real Passion" Konrad Bitterli

"Es ist ein grosses Geheimnis – wie der Geist funktioniert – wie er 'schöpferisch' sein kann.
Ich habe immer das Gefühl, dass ich ganz genau weiss, was ich tue, und zugleich, dass ich keine Ahnung habe, worum es
mir geht." [1] *Jessica Stockholder*

Welch abenteuerliche Symbiosen von Malerei und Skulptur, von der Fiktion des Bildraumes und der Realität der Objektwelt Jessica Stockholders "Geist" hervorgebracht hat, konnte man in den vergangenen Jahren anhand grossartiger Installationen verfolgen: eindrückliche Arbeiten von buntfarbener Fröhlichkeit, zusammengefügt aus vermeintlich wohlvertrauten Gegenständen des alltäglichen Gebrauchs, die beim Betrachten absurde Geschichten zu erzählen beginnen, während sie die Ausstellungsräume vollständig in Besitz nehmen und in entrückte Raumbilder auf Zeit verwandeln, in "Landschaften aus Materialassemblagen, Farben, Passagen und Lichtern". [2]

Auf Einladung des Kunstvereins St.Gallen hat die Künstlerin für den Oberlichtsaal des Kunstmuseums ein Werk konzipiert, das die spezifischen Gegebenheiten – die auf Durchblick angelegte Raumflucht, das fischgratgemusterte Parkett, die Wände mit dem mächtigen Zierfries und die quadrierte Decke mit Oberlicht – subtil aufnimmt, uminterpretiert und die klassizistische Architektur mit einer selbstbewussten Setzung neu erlebbar werden lässt. Dabei gelingt es ihr, den repräsentativen Charakter der historischen Architektur in einer theatralischen Geste von geradezu atemberaubender Leichtigkeit aufzuheben: "Vortex in the Play of Theater with Real Passion".

Im folgenden soll versucht werden, die Genese der Installation – das eingangs angesprochene Geheimnis des Geistes – schrittweise nachzuzeichnen und den langwierigen Weg von der Intention zur Realisation zu veranschaulichen, gewissermassen als schöpferische Bewegung vom Nichtwissen zum Wissen.

Zwei Aspekte gilt es dabei zu unterscheiden: die Ebene der gedanklichen Konzeption mit der dem weiteren Schaffensprozess zugrundeliegenden Auswahl der benötigten Werkstoffe und die Ebene der künstlerischen Aneignung des Raumes und der Inszenierung der Objektwelt. Dazu dient auch eine Serie von Zeichnungen, in denen sich die Künstlerin an die gedankliche Vorstellung ihrer Landschaft im Strudel von Theater und Leidenschaft herantastet und deren skulpturale Gestalt visualisiert.

Werkentwürfe

Als Jessica Stockholder, Jahre nach der ersten Kontaktaufnahme, im Mai 1999 das Museum besuchte, schlug sie intuitiv ein ortsbezogenes Werk für den zentralen Oberlichtsaal vor und erläuterte gleichzeitig ihre Arbeitsweise, für ihre vergänglichen Raumbilder jeweils auf die vor Ort erhältlichen Materialien zurückzugreifen und diese Vorgaben in eine sich prozesshaft entwickelnde Konzeption einfliessen zu lassen. Eine bei dieser Gelegenheit verfasste Aktennotiz listet dabei wahllos Elektroartikel wie Lichter und Lampen, Behälter jedweder Art, Second Hand-Möbel, Seile, Schläuche, Baumaterialien und Gartengeräte auf. Im Herbst 1999, die Ausstellung war inzwischen vereinbart worden, liessen wir der Künstlerin Versandkataloge für Büro- und Baubedarf sowie Einrichtungsprospekte für Haus und Herd zukommen. Darauf entspannte sich eine Korrespondenz, die Dutzende von Briefen, Faxmitteilungen sowie unzählige E-Mails umfasste und in deren Verlauf sich die Konzeption der St.Galler Arbeit langsam zu klären begann. So erreichte uns am 21. November eine erste Projektskizze, die in der detaillierten Auflistung unterschiedlichster Materialien bestand, verbunden mit der Bitte um genauere Abklärungen bezüglich Verfügbarkeit und Eignung: "Ich habe mit der Planung einer Arbeit für unsere Ausstellung angefangen. Obgleich ich erst am Anfang stehe, möchte ich Dich wissen lassen, worüber ich nachdenke. Die Kataloge, welche Du mir geschickt hast, waren sehr hilfreich, und ich würde weitere Zusendungen sehr begrüssen. Im Moment stelle ich mir vor, für den grossen Oberlichtsaal ein vergängliches Werk zu schaffen. [...] Für diese grosse Installation stelle ich mir

vor, sehr grosse Draperien zu verwenden, die von der Deckenwölbung zum Boden herunterhängen. Samtvorhänge vielleicht oder ein anderes Material, das leichter und auch kostengünstiger erhältlich wäre. [...] Ich würde auch gerne einen starken Theaterscheinwerfer einsetzen, der einen farbigen Lichtstrahl quer durch den Raum werfen könnte. [...] Im weiteren beschäftige ich mich damit, einige der kleinen Metallbehälter aus dem Katalog einzubeziehen. [...] Zudem habe ich eine Vorstellung, sehr viel Lego zu verwenden." [3]

Weitere Listen ergänzten und modifizierten in der Folge diese erste, und bis Anfang Dezember waren mit wenigen Ausnahmen – ein bunter Linoleumboden und eine Parkbank [4] kamen noch dazu – die Werkstoffe bekannt. Vorgesehene Eingriffe wie Malereien im Bereich der Wand und der sich gegen oben verjüngenden Decke wurden ebenfalls besprochen und zwischen Künstlerin und Museumstechniker auf ihre Realisierbarkeit hin diskutiert. Mittels zugesandter Proben bestimmte Jessica Stockholder die Farben eines Einlegebodens oder legte die Qualität eines Theatervorhangs fest. Die gewünschten Produkte galt es stets bezüglich ihrer Verwendungsmöglichkeit zu überprüfen: Masse waren abzuklären, Montageanleitungen zu studieren. Zu den notwendigen Abklärungen gehörten ebenfalls finanzielle Erwägungen, um gegebenenfalls kostengünstigere Alternativen zu prüfen, ohne die Konzeption des Werkes in Frage zu stellen. So mussten die ursprünglich vorgesehenen Behälter – es handelte sich um voll ausgerüstete mobile Büroräume – durch Materialcontainer in leuchtendem Rot, Orange und Blau ersetzt werden.

Trotz der meist ausführlichen Erläuterungen blieb die genaue Form der Installation während der Vorbereitungsphase und auch zu Beginn der Realisierung recht vage. Eine am 12. Januar 2000 übermittelte Grundrisszeichnung gab erstmals Hinweise auf Gestalt und Ausrichtung der Installation und legte insbesondere die Plazierung des Linoleumbodens fest, da dieser vor der Ankunft der Künstlerin in St. Gallen von einem Bodenleger zu installieren war. Allein, die Ausformulierung der künstlerischen Vorstellung war mit Beginn der technischen Umsetzung keineswegs abgeschlossen: Noch während des Aufbaus ergaben sich aufgrund der kontinuierlich vorgenommenen Überprüfung einzelner Interventionen immer wieder wesentliche Veränderungen. So wurden die gestische Wandmalerei der Lichtprojektion zugefügt genauso wie die leuchtenden Farbakzente auf Parkbank und Ytongturm. Gerade solche Detaillösungen und die unterschiedliche Volumina überspielenden leuchtenden Farbfelder sind es, die dem Schaffen der Künstlerin seine eigene Charakteristik verleihen. Dabei wurde eines deutlich: Jessica Stockholders Formvorstellungen waren in Bezug auf die räumliche Präsenz und die den ausgewählten Werkstoffen eigene Farbigkeit ausserordentlich präzise. Stets jedoch blieb ihre Konzeption offen für Fragen der technischen Machbarkeit wie für überraschende Wendungen, die sich erst aufgrund des Werkprozesses ergaben: "Ich versuche stets, so viel Chaos entstehen zu lassen, dass mein geordneter Gedankenablauf durcheinandergerät." [5]

Zeichnerische Annäherungen

Der Materialorganisation vorangegangen war eine Serie von acht Zeichnungen, welche der langsamen Annäherung an "Vortex in the Play of Theater with Real Passion" dienten: "Die Zeichnungen habe ich als eine Art Denkhilfe, was ich realisieren will, geschaffen." [6] Dabei gilt es grundsätzlich zwei Typen zeichnerischer Entwürfe zu unterscheiden: 1. Grundrisszeichnungen, welche als erstes die Verteilung der Volumen auf der Bodenfläche festlegen, und 2. Aufrisszeichnungen, in denen in ebenso skizzenhafter wie spielerischer Weise die Setzung verschiedener Gegenstände und Volumen im Raum erprobt wird. Vor allem letztere verdeutlichen die Variabilität von Jessica Stockholders Denken, indem unterschiedlichste Formideen entwickelt und diverse Materialien zeichnerisch auf ihre mögliche Verwendung hin erprobt werden.

Grundrissvariationen

"Att: Konrad Bitterli", war der am 12. Januar übermittelte Entwurf (Abb. S. 50) am linken Blattrand bezeichnet. In einem Querrechteck, der Auslegung des Ausstellungssaals entsprechend, sind verschiedene Volumen und Eingriffe als Grundrisse ins Bildfeld gesetzt: drei Materialcontainer, ein aus zwei runden Platten zusammengesetzter Tisch und darauf ein Turm aus Legobausteinen, eine Parkbank mit zwei dort angebrachten Theater-

scheinwerfern sowie eine die Diagonale des Raumes durchmessende Aufhängung mit Theatervorhang im Bereich der Containervolumen. Die Skizze selbst diente primär der Bestimmung und Plazierung des Linoleumbodens: # 5, # 7 und # 4 verweisen auf die Farbmuster, welche die Künstlerin vorgängig erhalten hatte. Darüber hinaus vermittelte die Zeichnung erstmals eine Vorstellung der geplanten Installation, wobei die Volumen deutlich benannt werden: "container", "curtain rod" usw. In hektischem, grün schraffiertem Strich ist, in die Bildfläche geklappt, eine für die Seitenwand vorgesehene Malerei angedeutet. Das Blatt – es kommt der realisierten Installation recht nahe – zeichnet sich formal durch die Nüchternheit der Darstellung aus: klare Linien, unmissverständliche Verteilung der Formen im Zeichnungsfeld und aufs notwendigste reduzierte schriftliche Hinweise. Es scheint vor allem auf Lesbarkeit und Verständlichkeit hin konzipiert zu sein.

Zwei weitere Grundrisszeichnungen lassen den keineswegs geradlinigen Weg der Künstlerin von der Konzeption zur Realisation erahnen. In einer eher flüchtig zu Blatt gebrachten Skizze (Abb. S. 50) sind einzelne Elemente – Container, Legoturm, Linoleumboden – ebenfalls bereits bestimmt. Dennoch zeigen sich bei deren Positionierung deutlich erkennbare Unterschiede: Die Containervolumen sind parallel zu der durchs Linoleum vorgegebenen Passage ausgerichtet, während der Körper aus Legoklötzen sich dahinter zu verstecken scheint. Die Wandmalerei – zwei, drei feste Striche nur – wird durch einen zweiten, von einem starken Theaterscheinwerfer auf die Wand projizierten Kreis verdoppelt. Der Theatervorhang als eine auf dem Blatt von links oben nach rechts unten verlaufenden Diagonale schert als einziges Element aus der längsgerichteten Reihung der Volumen aus. Diese wird in einem dritten Blatt (Abb. S. 51) konkretisiert und in eine festere zeichnerische Struktur überführt, wobei wiederum deutliche Verschiebungen festzustellen sind. Die Volumen – Container, Tisch und gestapelte Kohlebrickets – sind nicht mehr auf die Längsachse hin ausgerichtet, sondern in zwei parallelen Strängen diagonal in den Raum gesetzt und brechen dadurch die in der flüchtigen Skizze intendierte Axialität des Werkes zugunsten einer deutlichen Dynamisierung der Gesamtgestalt auf.

"Für gewöhnlich beginne ich mit den Grundrissen. Ich will mir zuerst klar darüber werden, wie ich die Verkehrsströme durch den Raum angehen will." [7] Diese Entwürfe bestechen durch die Klarheit der künstlerischen Vision, die sich in einer nüchternen zeichnerischen Sprache offenbart. Jessica Stockholder scheint sich die Volumen als Grundrisse gleichsam planerisch im Raum zu vergegenwärtigen, wobei mit Ausnahme des skizzenhaften Blattes eine grösstmögliche Klarheit der zeichnerischen Form intendiert ist. Schriftliche Erklärungen sowie einzelne Massangaben unterstützen den Charakter dieser Zeichnungen als eine Art von Planstudien, welche letztlich der Imagination freie Bahn gewähren.

Farbvolumen im zeichnerischen Raum

Im Gegensatz zu den formal eher strengen Grundrisszeichnungen überraschen die fünf skizzierten Aufrisse – ein Blatt aus der Serie entstand erst kurz vor dem Aufbau der Installation in St.Gallen – durch eine offene, im buchstäblichen Sinne "zeichnerische" Struktur. Der Strich, meist skizzenhaft-nervös, deutet mehr an als er ausformuliert, und dennoch ist er im Erschliessen des Raumes und in der Formulierung künstlerischer Vorstellungen von erstaunlicher Präzision.

Ein erstes Blatt (Abb. S. 51) gibt den Oberlichtsaal mit seinen beiden Eingängen, dem Gesims und der Deckenzone in knappen Strichen wieder; dazu eine Reihe von schnell umrissenen kubischen Körpern, die kompliziert ineinanderverschachtelt bzw. aufeinandergetürmt erscheinen und sich in ihrer genauen räumlichen Ausdehnung nicht unmittelbar erschliessen. Farblich hervorgehoben sind einzig ein Kreis und ein hochgestelltes Rechteck, die sich über Wand und Lichtzone erstrecken, sowie die kreisförmige Projektion eines kräftigen Scheinwerfers auf die Wand. Weitere Elemente wie eine Draperie zur Rechten bleiben flüchtig angedeutet und lassen sich aufgrund fehlender Erläuterungen nur retrospektiv identifizieren.

Ebenfalls äusserst skizzenhaft gehalten ist eine zweite Zeichnung (Abb. S. 52), die jedoch mit schriftlichen Hinweisen eine Entschlüsselung wesentlich erleichtert. Neben der deutlich erkennbaren raumquerenden Scheinwerferprojektion – in diesem Fall aus einer Ecke auf die Längswand – legt eine zweite Diagonale die

Aufhängevorrichtung mit einem mehrteiligen Theatervorhang – "curtain" – fest. Als zusätzliches, mit einer Legende versehenes Element hängt ein Trapez von der Decke, dessen Enden als feine Bleistiftstriche gegen den oberen Bildrand auslaufen. Keilförmige Strukturen im Bodenbereich lassen sich hingegen keiner konkreten Gestaltidee zuordnen.

Eine dritte Skizze (Abb. S. 52) gibt in feinen Bleistiftstrichen und kräftigen Buntstiftschraffuren eine Nahsicht des Raumes in Längsrichtung wieder. Zu erkennen sind im Vordergrund eine mehrbeinige, tischartige Tragstruktur mit einem darauf plazierten kubischen Körper sowie, durch eine von Tür zu Tür verlaufende blaue Linoleumpassage getrennt, im Hintergrund angedeutete Volumen und drei Wandmalereien in Grün, Violett und Orange. Diese erzeugen eine geometrische Komposition von ineinandergreifenden Flächen vor bzw. auf der Wand. In dieser Konzeption käme dem Bodenbelag, über den Besucher den Saal bzw. die Installation betreten, die Funktion einer klaren Zweiteilung des Projektes zu.

Die vierte Zeichnung (Abb. S. 53) gibt als einzige keine Längsansicht, sondern einen Querschnitt durch den Oberlichtsaal. Mit sich in der Perspektive dramatisch verkürzenden Linien werden Raum wie Deckenzone angedeutet. In dichter Überlagerung zeichnerischer Strukturen sind der kreisförmige Bodenbelag, eine ebenfalls kreisförmige Wandmalerei, eine Draperie, Metallbehälter und ein Betonblock erkennbar und mittels Hinweispfeilen und Legenden bezeichnet. Das Blatt selbst überrascht durch die entschiedene Vehemenz des Striches, der mit knappsten Mitteln die räumliche Situation umreisst und dabei gleichwohl eine autonome Bilddynamik entwickelt, wie sie für Jessica Stockholders zeichnerisches Schaffen charakteristisch ist.

Diese Dynamik wird in der in St. Gallen entstandenen Zeichnung (Abb. S. 53) durch das enge Zusammenrücken der Bildelemente im Zentrum des Blattes noch gesteigert. Der Blick fällt auf die mächtigen aufgetürmten Volumen mit Metallcontainern und eine nicht näher bezeichnete querrechteckige Struktur, auf den voluminösen Legoturm und die frei fallende Draperie, während im Vordergrund ein übergrosser Farbkreis die Wandmalerei andeutet und kräftige Striche die Lichtprojektion nachzeichnen. Dazwischen liegt der Bodenbelag, der gewissermassen die Bühne für das Spiel von Formen und Farben abgibt. Die Zeichnung, kurz vor dem Aufbau geschaffen, offenbart den Grad der Klärung, den die Konzeption der Installation von den ersten Skizzen bis zu diesem finalen Blatt durchlaufen hat. Sie verdeutlicht indes auch die Offenheit, die sich Jessica Stockholders Schaffen bewahrt, indem einzelne Eingriffe und ganze Formkonstellationen bis zur eigentlichen Realisierung im Raum noch entscheidende Veränderungen erfahren.

Visuelles Denken

"Die Zeichnungen sind Entwürfe für Arbeiten. Ich skizziere darin, wie ich den Raum angehen werde, wie die Arbeit ungefähr aussehen wird, und bis zu einem gewissen Punkt auch, welche Materialien ich verwenden werde. Während des Aufbaus der Arbeit wird vieles ganz anders, und die konkreten Details, die die Arbeit später stark bestimmen, kommen hinzu. Doch die Kontinuität zwischen Zeichnung und der fertigen Arbeit hat etwas Befriedigendes [...] zu sehen, wie eine abstrakte Vorstellung in meinem Kopf konkrete Gestalt annimmt." [8]

Jessica Stockholders Zeichnungen entstehen oft im Hinblick auf zukünftige Installationen und sind deshalb nicht ohne räumliche Umsetzung denkbar. [9] Es ist ihnen daher im Wesen eine dienende Funktion eigen, nämlich jene des langsamen Erarbeitens und Vergegenwärtigens einer gedanklichen Konzeption: "Zeichnen ist zuerst eine Art des Denkens. Es ist manchmal auch ein Kommunikationsmittel, aber ich glaube nicht, dass meine Blätter sich als direkte Kommunikation auszeichnen. Sie dienen auch als Erinnerung, so dass ich meine Ideen verfolgen kann." [10] Damit zielen die Zeichnungen aufs Zentrum ihres Schaffen, indem sich in ihnen die subjektive künstlerische Intention langsam konkretisiert, die Installation zeichnerisch Form annimmt, sich verändert, neu formuliert beziehungsweise als Erinnerungshilfe vorübergehend festgehalten wird. Im skizzenhaften Strich ist die Formsuche der Künstlerin spürbar, genauso wie das durchaus spielerische Ringen um Präzisierung der materiellen Bedingungen und räumlichen Setzungen stets präsent erscheint: "Gerade das Bestreben, zeichnerisch jede Perspektive zu brechen und sich den Raum als Bild vorzustellen, verweist im Entwurf deutlich auf das malerische Moment der Installation." [11]

Das Sich-Herantasten an eine private Vorstellungswelt im flüchtigen Medium der Zeichnung scheint die Künstlerin als Prozess gleichsam mühelos in den realen Raum zu übersetzen. Selbst der technische Aufbau der Installation folgt nicht so sehr einer bis ins Detail ausformulierten Konzeption oder einer strikten Planung, sondern entwickelt sich mit jedem vorgenommenen Eingriff weiter und lässt stets Raum für Veränderungen und unerwartete Wendungen, ohne dass das Werk ins Beliebige abgleiten würde. Beispielsweise findet sich die freie, geradezu gestisch wirkende Wandmalerei in keiner der Entwurfszeichnungen für "Vortex in the Play of Theater with Real Passion", wie überhaupt die Künstlerin einzelne raffinierte malerische Verbindungen erst abschliessend vornahm. Bei all diesen Eingriffen und formalen wie farblichen Transformationen überrascht der spontane und dennoch immer kalkulierte Umgang mit den durch jeden einzelnen Entstehungsschritt sich verändernden Strukturen, wobei der im Eingangszitat angedeutete Zwiespalt zwischen Nicht-Wissen und Wissen, zwischen Setzung und Öffnung, zwischen Chaos und Ordnung als ausserordentlich produktives Moment in die Werkgenese einfliesst. Der "Eindruck der Durchlässigkeit für alles, was sich während des Schaffensprozesses ereignet",[12] findet gerade in der Zeichnung einen kongenialen Ort des freien Imaginierens. Jessica Stockholders zeichnerisches Schaffen, die darin sich offenbarende Veränderbarkeit der Vorstellungswelt, bildet gewissermassen die Basis ihrer künstlerischen Tätigkeit, einen offenen Ort der Formfindung und -klärung im langsamen Prozess des Herantastens von der zweiten in die dritte Dimension. Und dennoch: Die Blätter sind nicht nur in ihrer Funktion auf dem Weg zum plastischen Werk von Interesse, sie überzeugen aufgrund ihres dezidierten Zugriffs auf das Medium, ihrer unverstellten Direktheit und Prozesshaftigkeit sowie ihrer ästhetischen Qualitäten letztlich auch als zeichnerische Form: als gültige Realisation in sich selbst.

1 Dialog zwischen Jessica Stockholder und Fabian Marcaccio, in: Ingvild Goetz, Christiane Meyer-Stoll, (Hrsg.), Fabian Marciaccio, Jessica Stockholder, München: Sammlung Goetz, 1999, S. 50.

2 Friedrich Meschede, "Laokoon oder die Grenzen von Skulptur und Installation bei Jessica Stockholder", in: Fabian Marcaccio, Jessica Stockholder, wie Anm. 1, S. 65.

3 Faxmitteilung der Künstlerin an den Autor vom 21. November 1999.

4 Faxmitteilungen vom 15. Dezember 1999 und vom 12. Januar 2000.

5 Wie Anmerkung 1, S. 50.

6 Die Künstlerin in einem E-Mail an den Autor vom 27. April 2000.

7 Ibid.

8 Jessica Stockholder im Gespräch mit Eva Schmid, in: Jessica Stockholder, Münster/Zürich: Westfälischer Kunstverein, Kunsthalle Zürich, 1992/93, S. 44.

9 Neben dienenden Zeichnungen entstehen auch Serien von autonomen Arbeiten und Collagen, in denen die malerische Konzeption ihres gesamten Schaffens offensichtlich wird.

10 Wie Anm. 6.

11 Wie Anm. 2, S. 70.

12 Christiane Meyer-Stoll, "Die Welt als lebender Organismus", in: Fabian Marcaccio, Jessica Stockholder, wie Anm. 1, S. 11.

From Conception to Realization
The Genesis of "Vortex in the Play of Theater
with Real Passion" Konrad Bitterli

"It is a mystery how the mind works – how it is able to be 'creative'. I always feel at once that I know exactly what I am doing and that I have no idea what I am about." [1] *Jessica Stockholder*

The adventurous symbiosis between painting and sculpture, between the fiction of pictorial space and the reality of the world of objects, which Jessica Stockholder's 'mind' has brought into being, could be followed these past years in superb installations: impressive works of colorful vivacity put together from supposedly familiar objects of everyday use, that completely take over the exhibition rooms and transform them temporarily into enchanted spatial images, i.e., "landscapes formed by the assemblages of material, colors, passages of light". [2]

At the invitation of the Kunstverein St. Gallen, the artist has conceived a work for the skylit main exhibition room of the museum that subtly takes up the neoclassical architecture, reinterprets it and makes it into a new experience by means of a bold intervention that mobilizes its available specifics: a spatial alignment that draws the eye along, the herringbone patterned parquet, the walls with their compelling frieze and the quadrangular ceiling with skylight. Yet she succeeds in preserving the representative character of the historical architecture within a theatrical gesture of breathtaking buoyancy: "Vortex in the Play of Theater with Real Passion". The following will attempt to trace the genesis of the installation step by step – the noted mystery of the artist's mind – and exemplify the long way from intention to realization, a so-to-speak creative transition from not knowing to knowing. There are two aspects that need to be distinguished: first, the level of mental conception with the choice of materials needed for its furtherance and, second, the level at which the artist adapts herself to the space available and dramatically stages the world of objects within its context. A series of drawings serves here to make the artist's mental preconception of the landscape understandable in "Vortex in the Play of Theater with Real Passion": a visualization of a three-dimensional configuration through the medium of the drawing.

Work drafts

When Jessica Stockholder, years after our initial contact, visited the museum in May 1999, she intuitively chose the central skylit gallery for a site-related work and explained her way of working: recourse to on-site materials as well as allowing the given conditions to flow into the conception in a give-and-take process. A note composed on this occasion randomly lists electrical appliances such as lights and lamps, containers of all kinds, secondhand furniture, ropes, tubes, building materials and gardening tools. In the autumn of 1999 – the exhibition had in the meantime been agreed on – we had mail-order catalogues sent to her on office and building supplies as well as folders on furnishing house and hearth. From here on a correspondence blossomed that comprised dozens of letters, faxes as well as countless e-mails, during the course of which the work slowly began to jell. Thus on 21 November a first sketch arrived that consisted of a detailed list of quite varied materials combined with a request for more precise details on their availability and suitability: "I have started to work on planning a piece for our exhibition and though I am still just at the beginning I want to let you know what I am thinking of. The catalogues you sent me have been very helpful and I would welcome any more you have to send. I am thinking that I will make one large ephemeral work for the large space with the skylights. [...] For the large room installation I am thinking at the moment of using some very large drapes that hang from the level of the molding to the floor. Maybe velvet drapes or perhaps another material that is easily and more cheaply available. [...] I would also like to use a powerful theater spotlight that is able to shine a beam of colored light across the room. [...] I am also interested in using some of the little metal rooms in the catalogue. [...] Also I have a fantasy of using a whole bunch of lego." [3]

Other lists subsequently supplemented and modified this first one and by the beginning of December the materials were known with few exceptions; a bright linoleum flooring and a park bench [4] were later added. Planned interventions, such as painting on the wall area and the ceiling that tapers towards the top, were also discussed by the artist

46

and the museum technicians as to their effectual realization. By means of the samples we sent her, Jessica Stockholder determined the color of linoleum or established the quality of a theater curtain. The desired products were constantly tested as to their applicability, during the course of which measurements needed to be taken, directions for assembly to be studied. One of the considerations was the financial aspect, which meant examining more cost-effective alternatives that didn't detract from the conception. For example, the containers originally planned for – these were fully equipped mobile offices – were replaced by room-sized storage containers in bright red, orange and blue.

Despite the usually detailed explanations, the exact form of the installation remained fairly vague during the preparatory phase and also at the beginning of its implementation. A sketch of the ground plan that we received on January 12, 2000, gave the first indications of the shape and arrangement of the installation and fixed the placement of the linoleum flooring, since this was to be installed by a professional before the artist's arrival in St.Gall. However, changes in the artistic concept were in no way at an end with the start of the technical execution: even during construction, essential changes were ongoing as a result of the constant scrutiny that individual interventions were subject to. Thus the gestural wall painting was added to the light projection just as were the accents of gaudy color to the park bench and the tower of porous concrete. It is exactly such detailed solutions and the bright, volume-offsetting color fields that characterize the artist's work. Meanwhile one thing became clear: Jessica Stockholder's artistic ideas concerning the spatial presence and the colors of the chosen materials were extremely precise. Yet her conception was constantly open to questions of technical practicability as well as to surprising changes of direction that the working process itself brought about. "I am always trying to create enough chaos to upset my ordered thought process."[5]

Visualization through drawings

The forerunner to any organization of the material was a series of eight drawings, which served as a gradual approach to "Vortex in the Play of Theater with Real Passion" – "I made the drawings as an aid to thinking about what I wanted to do"[6] – whereby two types of drawings need to be distinguished: 1. ground plans that first of all fix the way the volumes are apportioned and 2. outline drawing in which the placement of different objects and volumes in the room are sketched in and played out. It is especially the latter that make the variability of Jessica Stockholder's way of thinking clear, in that different formal concepts are developed during this drawing stage and diverse materials are tested for possible use.

Ground plan variations

"Att: Konrad Bitterli" was written on the left margin of the draft (ill. p. 50) sent on January 12. In a horizontal rectangle, which corresponds to the layout of the exhibition hall, different volumes and interventions were set as ground plans: three storage containers, one table made up of two round boards on which a Lego tower stands, a park bench with two theater spotlights mounted on it, a diagonal suspension across the room on which a theater curtain is hung near the containers. The sketch itself served primarily to define and place the linoleum flooring: # 5, # 7, # 4 indicate the color samples the artist had provisionally been sent. Beyond this, the drawing gave a first picture of the planned installation, whereby the volumes were clearly marked: "container", "curtain rod", etc. Folded into the picture plane, an indication of the painting on the side wall is given in hectic strokes of green hatching. The drawing, already quite close to the final realization, is characterized by the sobriety of its execution – clear lines, unmistakable assignment of the forms within the drawing, a minimum of written instructions – and seems above all to have been meant for easy decipherment and understanding.

Two further ground plans convey the in-no-way straight path from conception to realization. In a cursory sketch (ill. p. 50), single elements – containers, Lego tower, linoleum – were likewise determined. Yet their positions show clearly recognizable differences: the volumes marked as containers are parallel to the passage indicated by the linoleum, while the bulk of the Lego blocks seems concealed behind them. The wall painting – only two or three forceful lines – is doubled by means of a second circle projected onto the wall by a bright stage spotlight. The theater curtain, which runs diagonally across the plan from the upper left to the lower right, is all that breaks the horizontal line of the volumes. A third drawing (ill. p. 51) lends concrete form to this making it into a fixed, graphic structure, whereby clear shifts are again notable. The volumes – containers, table and a stack of coal bricks – are no longer arranged longitudinally

but set in two parallel lines diagonally to the room and break up the cursory sketch's intended axiality in favor of a clear, overall dynamism.

"Usually I begin with the ground plans. I first want to sort out how I will address the traffic pattern through the space."[7] These projects impress by the clarity of vision revealed by their sober graphic depiction. Jessica Stockholder seems to visualize the volumes as ground plans yet within a three-dimensional space, whereby, with the exception of the cursorily sketched plan, the greatest possible clarity is intended. Written explanations as well as individual details of dimensions shore up the character of these drawings as a type of planned study that, in the end, allows the imagination free range.

Drawing volume

In contrast to the formally rather strict ground plans, the five contour drawings (one in the series was not made till shortly before the installation was mounted in St.Gall) surprise us by an open, literally "graphic" structure. The line, mostly nervously sketchy, suggests more than it formulates, and yet it is surprisingly precise in its definition of space and statement of artistic concepts.

The first sketch (ill. p. 51) depicts in brief strokes the skylit gallery with its two entrances, the cornice and the ceiling, along with a series of hastily outlined cubic forms that appear to be complicatedly interlocked or heaped up and not readily intelligible in their dimensions. The only elements emphasized by color are a circle and a vertical rectangle that extend over the wall and the zone of light, as well as the circular projection of a powerful floodlight onto the wall. Other components such as the drapery on the right remain cursorily suggested and, because of the lack of explanation, can only be retrospectively guessed at.

A second drawing (ill. p. 52) is likewise extremely sketchy, but its written directions make it much more easily decipherable. Next to the clearly recognizable transversal floodlit projection – in this case from one corner onto the longitudinal wall – a second diagonal is set up by a device for suspending the sections of theater curtain. Additionally, a trapeze – an element indicated by a caption – is hung from the ceiling, the ends of which in fine pencil lines run out at the picture's upper margin. Wedge-shaped structures in the floor region, in contrast, cannot be assigned to any concrete idea.

A third sketch (ill. p. 52) reproduces in fine pencil strokes and powerful colored pencil hatching a close-up of the long view of the room. In the foreground a multi-legged, table-like supporting structure can be distinguished with a cubic form placed on it and in the background – separated by a blue linoleum-paved corridor that runs from door to door – a suggestion of volumes and three wall paintings in green, violet and orange. This makes up a geometric composition of interlocking planes in front of and on the wall. In this model, the flooring – over which the visitor must walk – is given the function of dividing the project very clearly in two.

The fourth sketch (ill. p. 53) is the only one that does not show a longitudinal view but a cross-section of the skylit central hall. Lines that dramatically shorten the perspective suggest room and ceiling. In a closely knit overlapping of graphic forms, the circular flooring, a likewise circular wall painting, drapery, metal receptacles and a concrete block are identifiable and captioned with directional arrows and captions. The drawing itself is surprising in the decisive vehemence of its stroke; by very concise means it outlines the spatial situation and thereby develops an autonomous pictorial dynamism, characteristic of Jessica Stockholder's graphic work.

This dynamism even increased in the drawing done in St.Gall (ill. p. 53), in that the pictorial elements are pushed into the center of the drawing. Our gaze is drawn to the mighty, stacked volumes with metal receptacles and to a horizontal rectangular structure not otherwise defined, to the voluminous Lego tower and the free fall of the drapery, while in the foreground an over-sized colored circle indicates the wall painting and powerful strokes trace the light projection. In between lies the flooring, which provides the stage, as it were, for the play of form and color. The drawing, done shortly before the building work was begun, reveals the degree of clarification that the conception of the installation went through from the first sketches to this final one. It also reveals the openness with which Jessica Stockholder approaches her work, in which single interventions and whole formal constellations up to the actual three-dimensional realization still manage to encompass decisive changes.

Visualized thinking

"The drawings act as outlines for the pieces. I map out how I am going to address the space, the feeling of what the piece will be like, and, to some extent, what the materials will be. During the process of building the work, things will change, and specific details, which will largely determine the work, are invented. But there is pleasure in the continuity between the drawing and the finished work ... to watch an abstraction in my head become so concrete." [8]

Jessica Stockholder's drawings often originate with a view to future installations and are thus not conceivable without a spatial manifestation. [9] They have, therefore, a ministering function, that of the gradual working out and visualization of a mental concept: "Drawing is first a way of thinking. It is sometimes a means of communication but I don't think my drawings excel as practical communication. They also serve as memory so that I can keep track of my ideas." [10] As such the drawings are at the center of her work, in that the subjective artistic intention is slowly made concrete, the installation takes on graphic form, changes, is newly formulated or is temporarily fixed as an *aide-mémoire*. The artist's search for form actually becomes quite tangible in the sketchiness of her stroke, just as the playful struggle to define the material conditions and the spatial placement appears to be constantly present: "It is exactly through the effort to break up every perspective graphically and to imagine the space as a picture that the painterly aspect of the installation is clearly reflected in the draft." [11]

How she feels her way towards a privately imagined world in the fleeting medium of the drawing is a process the artist seems to translate effortlessly into actual space. Even building the installation does not so much follow the details of a fully formulated conception or a strict plan, but continues to develop with each devised intervention and always allows room for variations and unexpected changes of direction without the work's ever becoming purely willful. For instance, in none of the blueprint drawings is an informal, even gestural wall painting for "Vortex in the Play of Theater with Real Passion" foreseen; in fact the artist waited to the end to paint in some of the subtle, all-encompassing tie-ins. With all these interventions and formal as well as chromatic transformations, it is the spontaneous and yet calculated way of managing structures and their change at every step that surprises. Here the artist's introductory quotation about her dichotomy between not knowing and knowing, between decisive placement and an opening up, between chaos and order flow into the genesis of the work as an extraordinarily productive factor. "Jessica Stockholder's works give the impression that they are permeable, open to everything that comes to pass during the creative process." [12] This permeability is especially perceivable in the drawing, where it finds a congenial place for an untrammeled imagination. Jessica Stockholder's graphic output, the mutability inherent in this imagined world, is the basis for her artistic activity, a medium open to finding and clarifying forms in the slow process of moving from the second to the third dimension. And yet: the drawings are not only of interest for their function as precursors to a sculptural form; they are convincing because of their specific use of the graphic medium, because of their undisguised immediacy and the process they lay bare and, in the end, because of their aesthetic qualities as drawings, as valid realizations in their own right.

Translation: Jeanne Haunschild

1 "Dialogue between Fabian Marcaccio and Jessica Stockholder" in Ingvild Goetz, Christiane Meyer-Stoll (eds.), *Fabian Marcaccio, Jessica Stockholder,* Munich, Sammlung Goetz (1999), p. 53.

2 Friedrich Meschede, "Laocoon or On the Limits of Sculpture and Installation by Jessica Stockholder", see n. 1, p. 72.

3 Fax sent by the artist to the author on November 21, 1999.

4 Faxes from December 15, 1999 and January 12, 2000.

5 See n. 1.

6 E-mail sent by artist to author on April 27, 2000.

7 Ibid.

8 Jessica Stockholder in an interview with Eva Schmid in *Jessica Stockholder,* Kunsthalle Zürich (1992/93), p. 43.

9 Along with drawings that serve to define an installation, the artist has also produced a series of autonomous works and collages in which the painterly conception of her whole oeuvre becomes apparent.

10 See n. 6.

11 See n. 2, p. 70.

12 Christiane Meyer-Stoll, "The World as Living Organism", see n. 1, p. 15.

painting on the wall →

Att: Konrad Bitterli

jondem #5

#7

wood grain #4

curtain rod

curtain

bench with two
theater light
attached

cinderblock

cameras

tables
spliced together-
legs cut off-
plywood on top-
legs or acrylic on top
of flect

50

Zeichnungen/Drawings

Seite 50
Vortex in the Play of Theater with Real Passion:
In Memory of Kay Stockholder, 2000
Bleistift, Farbstift, Faserstift und Kugelschreiber
auf Transparentpapier und Papier
21,5 x 28 cm

Page 50
Vortex in the Play of Theater with Real Passion:
In Memory of Kay Stockholder, 2000
Pencil, colored pencil, felt-tip pen, ballpoint
pen on transparent paper and paper
21.5 x 28 cm

Seiten 50 – 53
Vortex in the Play of Theater with Real Passion:
In Memory of Kay Stockholder, 2000
Bleistift und Farbstift auf Borden & Riley Bristol-
Papier
je 27,9 x 35,6 cm

Pages 50 – 53
Vortex in the Play of Theater with Real Passion:
In Memory of Kay Stockholder, 2000
Pencil and colored pencil on Borden & Riley
Bristol
27.9 x 35.6 cm each

Seite 53
Vortex in the Play of Theater with Real Passion:
In Memory of Kay Stockholder, 2000
Bleistift und Farbstift auf Strathmore Bristol-
Papier
35,6 x 43,2 cm

Page 53
Vortex in the Play of Theater with Real Passion:
In Memory of Kay Stockholder, 2000
Pencil and colored pencil on Strathmore Bristol
35.6 x 43.2 cm

Jessica Stockholder

1959 Geboren / Born in Seattle
Lebt und arbeitet / Lives and works
in New Haven, Connecticut

Einzelausstellungen (Auswahl) /
Selected Solo Exhibitions

1984 Art Culture Resource Center, Toronto;
installation: *In-side Out*

1985 Melinda Wyatt Gallery, New York;
installation: *Wall Sandwich*

1988 Mercer Union, Toronto; installation:
Indoor Lighting for my Father
Contemporary Art Gallery, Vancouver;
installation: *It's Not Over 'til the Fat Lady
Sings*

1990 American Fine Arts, New York; studio
works and installation: *Where it Happened*

1991 The Renaissance Society at the University
of Chicago; installation: *Skin Toned Garden
Mapping*
Witte de With, Rotterdam; studio works
and installations: *Near Weather Wall* and
Making a Clean Edge II

1992 Kunsthalle Zürich; installation: *Sea Floor
Movement to Rise of Fireplace Stripping*
Galerie Metropol, Vienna; studio works
and installation: *SpICE BOXed
Project(ion)*
Westfälischer Kunstverein, Münster;
installation: *Growing Candy Rock Moun-
tain – Grasses in Canned Sand*

1993 Galerie Ludwig, Krefeld; studio works
Galerie des Arènes, Carré d'Art, Musée
d'Art Contemporain de Nîmes, Nîmes;
installation: *Edge of Hothouse Glass*

1994 Weatherspoon Art Gallery, The Universi-
ty of North Carolina, Greensboro;
studio works and installation: *Pink Lady*

1995 Galerie Nathalie Obadia, Paris;
studio works
Dia Center for the Arts, New York; instal-
lation: *Your Skin in this Weather Bourne
Eye Threads & Swollen Perfume*
Jay Gorney Modern Art, New York;
studio works
Sala Montcada de la Fundación 'la
Caixa', Barcelona; installation: *Sweet for
Three Oranges*

1996 Baxter Gallery, Maine College of Art,
Portland; drawings
Tom Salomon's Garage, Los Angeles;
studio works and installation: *Bowtied in
the Middle*

1997 Kunsternes Hus, Oslo; installation:
*Slab of Skinned Water, Cubed Chicken and
White Sauce*
Otis Gallery of Otis College of Art and
Design, Los Angeles; drawings
Deutscher Akademischer Austausch-
dienst (DAAD), Berlin; drawings
Jay Gorney Modern Art, New York;
studio works

1998 Openluchtmuseum voor beeldhouw-
kunst Middelheim, Antwerp; installa-
tion: *Landscape Linoleum*
White Cube, London; installation:
Coupling
Musée Picasso d'Antibes, Antibes;
installation: *Torque, Jelly Role and Goose
Bump*
Musée des Beaux-Arts de Nantes,
Nantes; installation: *Nit Picking Trumpets
of Iced Blue Vagaries*

1999 Center for Visual Arts, Cardiff; installa-
tion: *With Wanton Heed and Giddy Cunning
Hedging Red and That's Not Funny*
The Power Plant, Toronto; installation
Galerie Rolf Ricke, Cologne; studio
works

2000 Kunstverein St.Gallen Kunstmuseum,
St.Gall; installations: *Vortex in the Play
of Theater with Real Passion* and *Making
a Clean Edge II*
Bucknell Art Gallery, Bucknell University,
Lewisburg, PA; studio works

2001 Gorney Bravin + Lee, New York;
studio works
Galerie Nathalie Obadia, Paris;
studio works
Galerie Nächst St.Stephan, Vienna;
studio works

Gruppenausstellungen (Auswahl) /
Selected Group Exhibitions

1988 The Mattress Factory, Pittsburgh;
 installation: *Mixing Food with the Bed*
1989 P. S. 1, Long Island City; installation:
 Making a Clean Edge
1990 Isabella Kacprzak Galerie, Cologne;
 "Mary Heilmann, Jessica Stockholder";
 installation: *For Mary Heilmann*
 The Whitney Museum of American Art
 at Equitable Center, New York;
 "Contingent Realms"
 Le Consortium, Espace Frac and L'Usine,
 Dijon; "Le Choix des Femmes";
 installation: *Recording Forever Pickled*
1991 Chateau d'Oiron, Oiron; "Le Consortium
 collectionne"; installation: *Recording
 Forever Pickled*
 Whitney Museum of American Art,
 New York; "1991 Biennial"; installation:
 Recording Forever Pickled Too
1992 Witte de With, Rotterdam; "As Long as it
 Lasts"; installation: *Catcher's Hollow*
1994 Hayward Gallery, The South Bank Centre,
 London; "Unbound: Possibilities in
 Painting"; installation: *Fat Form and
 Hairy: Sardine Can Peeling*
 Pat Hearn Gallery, New York;
 "Mary Heilmann, Jack Pierson, Jessica
 Stockholder"
1995 Rooseum, Malmö, Magasin 3, Stock-
 holm; "Painting the Extended Field";
 installation: *Bowtied in the Middle*
1997 Halle Tony Garnier, Lyons; "4e Biennale
 de Lyon"; installation: *Bowtied in the Middle*
 Cordiere, Venice; "La XLVII Biennale
 di Venezia"; *Recording Forever Pickled*
1998 Museum Ludwig Köln, Cologne; "I Love
 New York: Crossover der aktuellen
 Kunst"; studio works
 Kunsthalle Zürich, Zurich; "Auf der Spur:
 Kunst der 90er Jahre im Spiegel von
 Schweizer Sammlungen"; studio works
 Centre Georges Pompidou, Paris; "Dijon/
 Le Consortium collectionne"; installa-
 tions: *House Beautiful* and *Recording
 Forever Pickled*
 Saatchi Collection, London; "Young
 Americans 2"; studio works and installa-
 tion: *Bowtied in the Middle*
2000 Sprengel Museum, Hanover; "Aller
 Anfang ist Merz – Von Kurt Schwitters
 bis heute"; installation: *Gelatinous Too Dry*
 Haus der Kunst, Munich; "Die scheinba-
 ren Dinge: Der Gegenstand in der Kunst
 des 20. Jahrhunderts"; installation:
 Pictures at an Exhibition

Werke in öffentlichen Sammlungen /
Works in Public Collections

Albright-Knox Art Gallery, Buffalo
The Art Institute of Chicago, Chicago
The British Museum, London
Carré d'Art, Musée d'Art Contemporain de
Nîmes, Nîmes
Centraal Museum, Utrecht
Corcoran Gallery of Art, Washington, DC
Fonds Régional d'Art Contemporain – Limou-
sin, Limoges
Kunstmuseum St.Gallen, Kunstverein St.Gallen;
installation: *Vortex in the Play of Theater with
Real Passion*
Le Consortium, Dijon; installations:
House Beautiful and *Recording Forever Pickled*
Los Angeles County Museum of Art, Los Angeles
Musée Picasso d'Antibes, Antibes; installa-
tions: *Torque, Jelly Role* and *Goose Bump*
Museum Moderner Kunst Stiftung Ludwig,
Vienna; installation: *Nit Picking Trumpets of Iced
Blue Vagaries*
Stedelijk Museum, Amsterdam; installation:
Coupling
Weatherspoon Art Gallery, The University of
North Carolina, Greensboro
Westfälischer Kunstverein, Münster
Whitney Museum of American Art, New York